Cotherstone
A Village in Teesdale

Paul Rabbitts & David Rabbitts

AMBERLEY

We dedicate this book to Morlene Rabbitts, mum, wife and resident
of Cotherstone since 1964, and an incredible woman

'To the man or woman who is desirous of finding the best in this country I commend the
English village.'

Edmund Blunden, poet, author and critic (1896–1974)

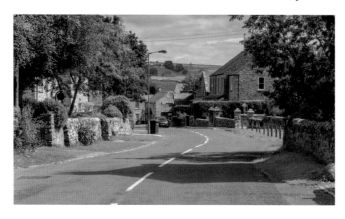

Moor Road, Cotherstone.

First published 2022

Amberley Publishing
The Hill, Stroud,
Gloucestershire, GL5 4EP

www.amberley-books.com

ISBN: 978 1 3981 1383 1 (print)
ISBN: 978 1 3981 1384 8 (ebook)

British Library Cataloguing in Publication Data.
A catalogue record for this book is available from the British Library.

Typeset in 10pt on 13pt Celeste.
Typesetting by SJmagic DESIGN SERVICES, India.
Printed in the UK.

Contents

ERRATA
P88 4th line up should read Katherine Birkett, not Dorothy Birkett

Introduction

Life in a Village

In 1914, author Ernest Bennett wrote in *Problems of Village Life*: 'In the midst of the great industrial developments which followed the close of the Napoleonic war the claims of the rural population were to a large extent overlooked.' Bennett describes, 'the attention of our country and those who guide its destiny is chiefly centred upon urban interests and urban demands', and that our nation has learnt little about the true value of 'our fertile fields and the men who cultivate them'. He was writing in 1914, over 100 years ago, and the changes since then in village life have been unprecedented. It is almost laughable when Bennett talks of the 'rural England today' and how the agricultural labourer of the North earns considerably higher wages than his brother in the South, sharing to some extent 'in the self-confident and independent character of the artisans of great industrial towns'. It would seem that dear old Ernest Bennett had never visited the hill-farming settlements of rural North Yorkshire or County Durham, especially the Dales villages we know so well today.

In 2019, author Robin Page, who wrote *The Decline of an English Village*, is at times effusive about life in rural England. After the Second World War, life seemed peaceful, even though conditions during wartime had at times seemed much more financially secure. Farms, though, were still very much a mixture of extremely small fields, along with copses, including arable and pastoral, and progress in mechanisation was incredibly slow, with a strong reliance still on horsepower and manual labour. Beyond these many farms that made up rural England, though, are many of our villages. These villages will often have their origins going back hundreds of years, from the Norman invasion to Saxon settlements, Roman occupation and beyond. To this day the past of these villages is often still visible, from the ancient towers of village churches with their steeples to the ancient ridge and furrows caused by strip-farming husbandry from earlier generations.

The history of our villages is captured in an excellent book, written in 2010 by author Clive Aslet, called *Villages of Britain: The 500 Villages That Made the Countryside*. Here, the story of the village is described as that of the countryside itself. But villages have changed; they have always changed. As Aslet describes, they 'form, they grow, they morph, they shrink, they grow again. Sometimes they disappear'. Many of these villages started as dormitory settlements, providing roofs over the heads of the families who 'toiled on the lord's fields and kept his sheep. Managed his woods or dug his mines'. Early village life,

and their establishment, is rarely documented as most were not formally planned, since they evolved over time. Dating back to medieval times, the dwellings would have been insubstantial, poorly built and probably centred around a green or a church, and most likely as a result of farming practices. By the tenth century most farming was conducted using an open field system. Areas of land were divided up among different families, each of whom cultivated a number of strips, creating the ridges and furrows we often see today. This kind of agriculture required considerable cooperation and as a result, farmers, smallholders and cottars (landless labourers) would live together in a village. The spread of this open field system was quickly accelerated during Norman times, the beginning of a feudal hierarchy under which peasant farmers were eventually compelled to work in the fields owned by the lord of the manor, as well as their own. These were tough times, often exacerbated by disease, such as the Black Death of the fourteenth century with the loss of at least a million people. Villages were often abandoned and where they survived villagers would often look at other ways of making a living or supplementing their income from agriculture.

Villages often had a number of industries, such as weaving, fishing (if coastal) and, if within the hills of the Pennines, the mining of lead – what became known as a dual economy. In essence, villages did many things, but up until the beginning of the nineteenth century most of them were agricultural, with their inhabitants primarily working on the land. Change came with the mechanisation of agriculture and the growth of our industrial urban towns and cities with mass migration from rural communities to the rapid industrialisation of our nation. The population of the country in the middle of the eighteenth century was only 6 million, with only 1 in 5 living in a town of any size. By 1851, the population had risen to 18 million, with an equal split between urban and rural. However, in 1911, the situation was very different, with the population reaching 40 million and 80 per cent living in towns such as Manchester, Liverpool, Leeds, Birmingham and Newcastle, and the growing conurbation on Teesside and Wearside. The exodus to these growing urban settlements and the increase in mechanisation led to immense changes in villages across the country, especially in northern regions where life was already very challenging. The exodus was further exacerbated with the decline in mining. Conditions in

Ridge and furrow.

the 'dark satanic mills' was deemed dreadful, but life on the land in many rural areas was much worse. Since the middle of the twenty-first century there has been a total reversal: farming now employs hardly anybody, such has been the advancements in mechanisation and agricultural methods. In his book *English Villages*, John Burke devotes a whole chapter to change and decay. Rather frankly, he states that it is 'absurd to hope for a return to that never-never land of rosy-cheeked cottagers happy in their daily toil, touching their forelocks to a beneficent squire, asking no more than the simple joys of market day, the annual fair, and dancing round the maypole on the village green'. Burke writes in 1975 – nearly fifty years ago – and already he talks of villages owing their existence to prosperous weekenders or retired people whose longing for a country cottage or rural existence has inflated house prices until it has become impossible for those born locally to buy a home of their own. This has been termed 'geriatrification' in some circles, with the once great industries replaced with tourism and retirement, and much of the village population commuting to jobs elsewhere. Whilst many of these newcomers have restored buildings once devoted to farming, with local industries long since gone, such restoration has often added to the picturesque quality and charm of these villages. The impact, though, on these communities has been dramatic, with the loss of schools, shops, post offices, petrol stations, the local policeman, milkman and, in many instances, the local pub. Many become dormitory villages, isolated, and displaying characteristics of lifelessness and, at times, abandonment. Despite these losses, many other villages to this day exhibit the qualities of tranquil harmony and quiet delight and make up the picturesque chocolate-box imagery of rural England in the twenty-first century.

Clive Aslet sums this up beautifully: 'One of the wonders of villages is how generations of often anonymous people have worked, incrementally, to make them more convenient to live in, and more harmonious to the eye. Their labours have made my village odyssey a delight.' This is none more so apparent than in Teesdale, where we are endowed with some of the finest villages in England, from Middleton-in-Teesdale and Newbiggin at the upper end of the dale to Romaldkirk, Eggleston, Mickleton and Lartington mid-dale, and to the lower end of Teesdale the villages of Gainford, Piercebridge and Staindrop. In the centre of Teesdale, though, is the beautiful village of Cotherstone. It was described in February 1891 in *North-Country Lore and Legend*: 'Cotherstone is a quaint little place and pretty. There is a pleasant sort of air about it that is impossible to describe; you must be there to experience it for yourself.' Allan Ramsden, writing in the *Teesdale Mercury* of 29 March 1916, describes the village as follows:

> Cotherstone, you repeat, the word has in it a charm, especially to those people who have been there. It is redolent of sweet heather scented zephyrs from the wild moor, and of flowers from the woods, of the music of purling brook and swiftly flowing rivers; of skylarks in the meadows, and other bird song; of primrose, honeysuckle and wild rose. It reminds the patient angler of numerous trout and salmon, and their natural enemies – the otter and the heron. To the artist who has been there, Cotherstone comes as a delightful visions, wooded landscapes, quaint old thatched houses, rustic lanes and old corn mills, with here and there a silent waterwheel. Legend and history, too, give it a mystic fringe.

It is to Cotherstone, our village in Teesdale, that we will now turn to.

1

Teesdale: The Valley of the River Tees

The three principal rivers of the North East of England are the Tyne, Wear and Tees. Each of these mighty rivers has shaped the history of our region, its culture and our communities. The River Tees, stretching from its source on Cross Fell in the High Pennines to Teesmouth via Barnard Castle, Darlington, Stockton-on-Tees and Middlesbrough, is the most southerly of them all. There are tales and legends associated with this river, which covers Roman forts, medieval settlements, the manufacturing heartlands of Middlesbrough with incredible industrial heritage, as well as Areas of Outstanding Natural Beauty. Authors Tosh Warwick and Jenny Parker in their book *River Tees: From Source to Sea* describe the importance of the river in shaping the identities of the areas that exist alongside. It drains an area of over 700 square miles and is over 85 miles in length, passing through high moorlands of peat to salt marshes, where it meets the North Sea. Prior to local government reorganisation in 1974, the River Tees also formed the boundary between the counties of Yorkshire and Durham. Many today who live on the south side of the Tees still consider themselves part of Yorkshire. Old habits die hard.

The river draws its water from the slopes of Cross Fell and Mickle Fell. The scenery here is shaped on the underlying masses of the Yoredale rocks, which after hundreds of years of weathering have left the terraced slopes, the limestone scars and the long ridges so associated with this distinctive landscape. The igneous rocks of the Whin Sill, which were injected molten lava into the carboniferous rocks, have left us with huge, craggy escarpments and the magnificent waterfalls of High Force and Cauldron Snout. Douglas Ramsden, writing in 1947 in *Teesdale*, tells of austere fells that nourish the river and the valley below. The Tees means much to the people of the dale, who have lived here for centuries, and even so today, although to a much lesser extent.

The origin of the name 'Tees' has puzzled historians for many years. It is mentioned in the *Knytlinga Saga*, a history of the Danish kings of the tenth and eleventh centuries, and in later records is referred to as Teisa and Taise. There has also been reference to it from the Welsh *tes*, which means 'heat or sunshine' and is often translated as the 'boiling surging river'. William Camden (1551–1623) describes the bishopric of Durham with the River Tees on its way to Barnard Castle, where the hard limestone or 'marble' at Egglestone Abbey is quarried:

The river that boundeth the South part of this country is called by Latin writers *Teisis* and *Teesa*, commonly Tees ... Tees springeth out of that stony country called Stanemore, and, carrying with him away in his chanell along, many brooks and beckes on each side, and running through rockes (out of which at Egleston, where there is a marble Quarroy, and where Conan Earle of Britaine and Richmond founded a small Abbay), first beateth upon Bernard Castle, built and so named by Bernard Balliol the great grandfathers father of John Balliol King of the Scots.

There are also many tributaries of the Tees that have carved out their own valleys into the fells, which often have their own distinctive characteristics. These include the Lune, the Greta and, locally, the River Balder. The latter may well take its name from Balder, the Norse god of light and innocence. Balder was the son of Odin and Freyja, who could be described as 'King and Queen of the Gods'. It has been suggested that there are earthworks close to the village of Cotherstone that are perhaps the remains of a Viking temple to honour Balder. Sir Walter Scott sets the scene:

> When Denmark's raven soared on high,
> Triumphant through Northumbrian sky,
> Till, hovering near, her fatal croak
> Bade Reged's Britons dread the yoke;
> And the broad shadow of her wing
> Blackened each cataract and spring,
> Where Tees in tumult leaves his source,
> Thundering o'er Caldron and High Force.
> Balder named from Odin's son;
> And Greta, to whose banks ere long
> We lead the lovers of the song;
> And silver Lune from Stainmore wild
> And fairy Thorsgill's murmuring child

Thor was, of course, the god of Thunder, while Odin, the one-eyed god of wisdom, poetry, agriculture, war and death, is also commemorated in the locality under his Anglo-Saxon name of Woden at a place called Woden Croft. This place and the name of the River Balder certainly captured the imagination of Sir Walter Scott, in his poem 'Rokeby' of which verses are quoted above and below:

> Beneath the shade the Northmen came,
> Fixed on each vale a Runic name,
> Reared high their altar's rugged stone,
> And gave their gods the lands they won.
> Then, Balder one bleak garth was thine,
> And one sweet brooklet's silver line;
> And Woden's croft did little gain
> From the stern father of the slain.

Many of the names of these Viking and Anglo-Saxon gods are very familiar to us today and especially if today happens to be Wednesday, Thursday or Friday. These are, needless to say, the celebrated days of Woden, Thor and Freyja.

The River Tees and River Balder have played a significant part in the evolution, history and geography of the village, from industry with watermills to latter days as an attraction bringing tourism and recreation, with the natural history and geology playing a significant role up until present times. The Fairy Cupboards are well known locally as a geological

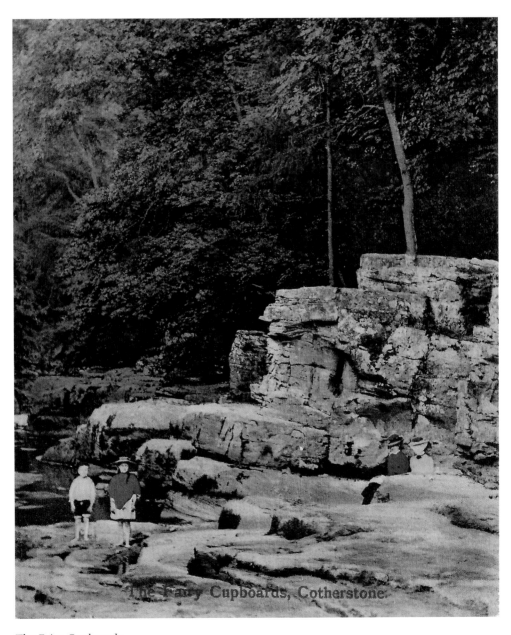

The Fairy Cupboards.

phenomenon and have been visited since Victorian times, frequently appearing on early postcards sent home by visitors. The *Teesdale Mercury*, on 29 March 1916, describes them as 'a series of caves ... formed with wrought columns at the entrance. This is Fairy Cupboards ... by rustics named when nature's ways were little understood'.

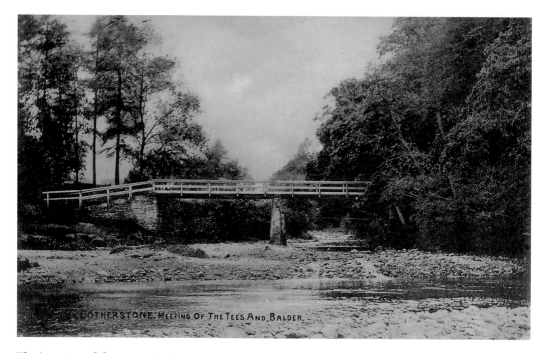

The 'meeting of the waters', where the Balder meets the Tees.

Looking down towards the 'meeting of the waters', often known as 'Surprise View'.

The view today, Surprise View. (Image courtesy of Richard Laidler, middletonphotos.co.uk)

Further downstream is the 'meeting of the waters' where the Balder joins the Tees, and it is here where the rivers have had a dramatic effect over many centuries. Allan Ramsden in 1920 talks of a 'gravel cart road down the hill which leads to the Hagg … a great natural amphitheatre of striking beauty, covered with a carpet of rich green herbage. Here Balder has done his work well'. Long after the Ice Age, the Balder would frequently flood and bring down immense quantities of stone, earth and clay, which would be deposited further downstream – in this case at the Hagg, where the water would spread out, losing its force. As a consequence, the river would often change course and direction. Eventually, the river's course round the south side of the Hagg became blocked, and the Balder turned to hug the north bank, eventually carving out the Hagg and the large amphitheatre we see today. It is dramatic, and it is no surprise that it was above the Hagg that Cotherstone Castle was eventually built.

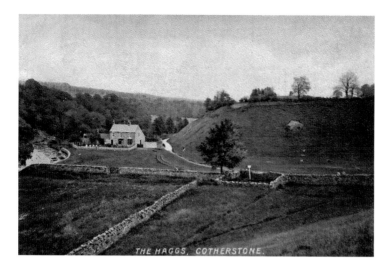

THE HAGGS, COTHERSTONE.

Left: The Hagg with Hagg House in the middle ground.

Below left: Suspension bridge over the River Tees.

Below right: A scene of great tragedy and loss of life in 1929.

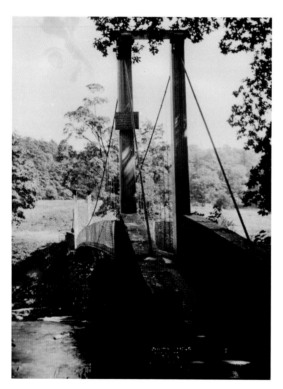

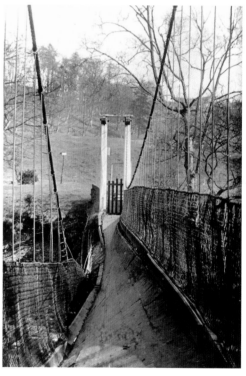

The meeting of the waters was also once the scene of a great tragedy. The footbridge over the Tees was built in 1932 by Joseph L. Thompson & Sons Ltd of Sunderland. It replaced two earlier bridges: a timber bridge, which was replaced following flood damage in 1881, and a suspension bridge, whose cable snapped in 1929 – forty people were on the bridge at the time and sadly there were fatalities. Thankfully, today it is a much more tranquil scene that greets residents and visitors alike.

2

The Early History of Cotherstone

Cotherstone village lies in the valley of Teesdale where the River Balder joins with the River Tees at the 'meeting of the waters'. It is located downstream from the ancient village of Romaldkirk, famous for its magnificent church and only a few miles from the medieval market town of Barnard Castle, the principal town of the dale. Exploring the village reveals a small network of back lanes and passageways barely large enough to squeeze a vehicle down, but often open out on to the village's two picturesque greens, East Green and West Green. Many of the older houses that remain in the village were once farmhouses and cottages, built mostly in the seventeenth and early eighteenth centuries.

Above the village is the bleak expanse that is Cotherstone Moor. It is here that some of the earliest remains in the area have been found. The moor is particularly rich in the mysterious prehistoric rock carvings known as cup and ring marks. These were most likely to have been carved in the late Neolithic or early Bronze Age. The exact meaning of the designs remains unknown, but they may be interpreted as sacred or religious symbols. Frequently they are found close to contemporary burial monuments, and the symbols are also found on portable stones placed directly next to burials or incorporated in burial mounds.

The carvings on the three rocks on Goldsborough Rigg, Cotherstone Moor, 860 metres south-south-east of Pitcher House, survive well and they are some of several carved rocks in the Goldsborough area.

In addition to these carvings there are other reminders of prehistory, such as the Bronze Age ring cairn at Goldsborough; flint tools have been found nearer the village; and one Bronze Age stone axe was even built into an eighteenth-century barn, possibly to ward off bad luck.

Like many areas of Teesdale, the arrival of the Romans in the first century AD appear to have little effect on local life. No roads ran through the area and the nearest Roman fort of any size would have been at Greta Bridge. Cotherstone seems to have remained quiet in the Anglo-Saxon period, although the name of the village itself is Old English – it was first recorded as Cudrestone in the Domesday Book and is thought to mean 'Cuthere's farmstead'. Beyond this place name little survives. A fragment of a stone cross of eighth- or ninth-century date was found built into a barn at Thwaite Hall; however, it is not known where it originally came from, and it may not have come from the village. It has also been suggested a settlement up on the moor at West Loups may have been used during this period, though there is little hard evidence for this.

Cotherstone, looking back from Cotherstone Moor.

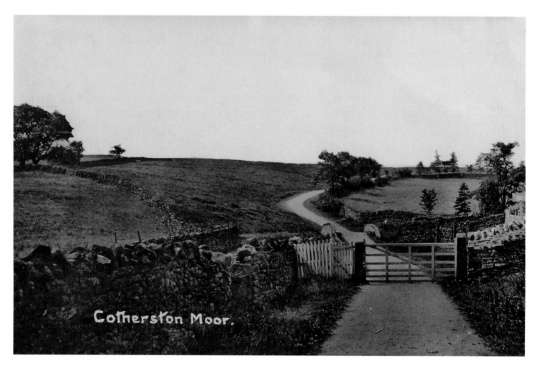

Heading out to Cotherstone Moor.

Cotherstone Castle

It was during the medieval period that the village became more important. A castle was built around 1090. It was one of a line of castles surrounding the entrance to Teesdale and was originally a Norman motte-and-bailey castle. A royal licence to crenellate (fortify) was granted on 2 March 1201, indicating a later stone building. Local legend suggests the castle was destroyed by the Scots. This fortress was apparently fortified, if not erected, under a licence of King John in 1200–01 by Henry, son of Hervey, and continued with his descendants, the Fitz Hughs of the manor of Cotherstone. Little is known of its history, nor when it became a ruin. There was certainly a 'motte' with evidence of a possible stone keep on it and some lower defensive works. Apparently, the original approach follows a track that leads east from the village and, as it enters the outworks, becomes a mere causeway defended on the north by a very steep escarpment where the natural fall of the ground has evidently been increased by artificial work. On the south side there is also a considerable fall.

The chief traces of the castle buildings lie in a field to the north of the track and consists of grass-covered mounds forming the foundation of two concentric lines of defence. On the summit of the hill a large, flat-topped mound still retains a short length of wall, of which nothing can be said except that it is an external wall. West of the keep is a well, constructed with good masonry, which supplied water for the neighbouring cottages and was evidently the original source of supply for the castle. Of the large quantity of masonry that composed the castle, few traces are now to be seen, though doubtless much of it passes unrecognised in the building and walls of the neighbourhood. A cottage on the north side of the track

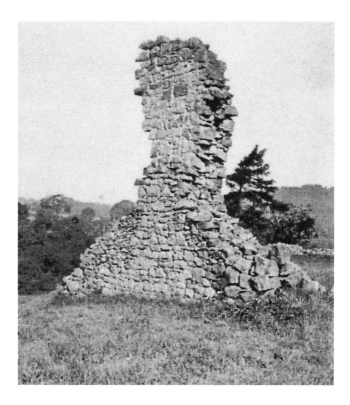

Cotherstone Castle – as captured by photographer Elijah Yeoman.
(© Parkin Raine Collection)

All that remains of Cotherstone Castle today.

to the village has some fragments of worked stone built into its south wall. These include the double head of a small two-light, round-headed window; a single head; a portion of the cusped head of a small window; a portion of a thin octagonal shaft and capital; and a section of a string course and some other smaller fragments. Some pieces of worked stone, which came from the site of the castle, are now in the rectory garden. Amongst them is a rudely cut grotesque head, probably the terminal of a label; two of a similar type are in position on the north door of Hutton Magna Church. Today it is a Scheduled Ancient Monument.

The Manors of Cotherstone, Hunderthwaite and Lartington – The Fitz Hughs and the Fitz Alans

These were tough times and the building and ultimate demise of Cotherstone Castle was testament to this. Upper Teesdale had previously been laid to waste by the Scots as early as 1070: An 'infinite multitude' under King Malcolm entered Yorkshire from Cumberland and may have saved William I the trouble of devastating Romaldkirk village, which was laid to waste in 1086, 'for they slew in battle several English nobles at a place in Teesdale called in English Hundredeskelde' – in Latin, Centum fontes. This was almost certainly the adjacent hamlet of Hunderthwaite, located half a mile south-west of Romaldkirk, which still might be called the Hundred Springs. King Malcolm, retaining part of his army, sent the other part home 'with countless booty'. Romaldkirk parish naturally suffered considerably in border warfare, and in 1340–41 forty carucates (a medieval unit of land

an oxen team could plough in a year) were said to have been wasted by the Scots. The boundaries between Yorkshire and Westmorland at this point were probably placed in the middle of the fourteenth century, following a circuit made in consequence of cross cattle raids made by the lords of Mickleton in Teesdale, Yorkshire, and of Brough and Stainmore in Westmorland in 1335–38.

Since the Conquest there have been two manors of Cotherstone, one of which descended from Bodin to the Fitz Hughs. As previously referred to, Henry, son of Hervey, had licence in 1200–01 to fortify his house here, which became the aforementioned Cotherstone Castle, and in 1251 Henry, his grandson, was granted free warren in his demesne lands of Thringarth, Mickleton, Cotherstone, Briscoe and Holwick. Hugh, son of Henry (from whom the Fitz Hughs take their name), was summoned in 1278–81 to substantiate his claim to have free chase in Teesdale, free warren and park at Cotherstone, and gallows in his lands. Hugh pleaded his ancestors' right to chase from the first grant of their lands, warren he claimed by a charter of Henry III, and gallows he only claimed at 'Barwick on Tees and Stanck'. This manor followed the descent of Ravensworth until the sixteenth century, when it reverted to the Crown. In 1600, the queen granted the manors of Cotherstone and Lartington to Alexander Edward and Richard Prescott, who in 1602 conveyed them to Elizabeth, Countess of Shrewsbury, then in her third widowhood. 'Building Bess of Hardwick', as this lady was called from the series of marriages by which she raised her status, settled them the same year on her son Lord William Cavendish. Her descendants, the earls of Devon and dukes of Devonshire, were lords of Cotherstone until 1841, when the Duke of Devonshire sold it to John Bowes, from whom it has descended to the present Earl of Strathmore.

Cotherstone with Hunderthwaite was the other manor of Cotherstone and was held by the Fitz Alans. Between 1278 and 1281 Brian Fitz Alan alleged that he had free warren at Cotherstone by grant of King John to Brian, son of Alan, his ancestor in all his demesne lands outside the king's forest, and that Brian had his private woods in his manors and had enclosed them and made the park in which he had warren. After the death of Brian Fitz Alan without male issue early in the fourteenth century, his daughters and their descendants, the Stapletons and the Greys of Rotherfield, held some of his manors jointly, but Cotherstone was held separately by the Stapletons. In 1354, Miles Stapleton settled the manor of Cotherstone and his part of Bedale on his male heirs by Joan, his wife, and his brother Brian. When, however, Sir Miles Stapleton died without male issue in 1466, although male descendants of Brian still existed, the manor passed to Joan, younger daughter of Sir Miles, married first to Christopher Harcourt and secondly to Sir John Huddleston of Millom Castle, Cumberland. In 1470, Brian Stapleton, descendant of Brian, sued Richard Harcourt, son of Sir Christopher and Joan, for this manor, basing his claim on the settlement of 1354. He recovered Bedale, but not Cotherstone, of which Sir John Huddleston Kt took ownership in right of his wife in the reign of Henry VII. The Huddlestons of Millom Castle continued in possession until 1741–42, when William Huddleston sold the manor of Cotherstone with Hunderthwaite to George Bowes of Streatlam, ancestor of the present owner, the Earl of Strathmore.

Hunderthwaite, like the Fitz Alan manor of Cotherstone, seems to have belonged to that family in the reign of King John, for in 1246 Alan, son of Brian, complained that Henry, son of Ranulf, entered his free warren of Hunderthwaite and captured hares and wild goats

there. Although Alan had free warren by the charter of King John, Henry 'quitclaimed' his right. The Abbot of St Agatha's claimed the manor in 1251–52 in right of his church, which, he said, was taken in the time of Henry II, but in the same year he released his claim on the manor to Alan, son of Brian, in return for lands in Scruton. The immediate history of Hunderthwaite is slightly obscure. In 1286–87 it was coupled with Romaldkirk as Romaldkirk-cum-Hunderthwaite, the Hunderthwaite part being held by Brian Fitz Alan. A return dating to the reign of Henry VII couples them in the same way and shows them as belonging to the Fitz Hughs. The latter return, however, probably only referred to services, as Hunderthwaite seems always to have belonged to the descendants of the Fitz Alans. It was held by the dowager Maud of Bedale in 1316, and the Grays of Rotherfield held it at the end of this century. The Grays and Stapletons seem to have shared it, for it passed ultimately to the Huddlestons, being held in 1677–78 with Cotherstone by Ferdinand Huddleston as one manor. These two estates have continued to be manorially united.

Lartington, between 990 and 1020, was pledged with Barforth by the Bishop of Durham to 'Eorl' Ughtred of Northumbria and two Danes. It was one of the manors of the Richmond fee that in the middle of the fifteenth century became part of the fee of Middleham (q.v.) and ceased to be a member of the honour of Richmond.

The mesne lordship descended from Bodin to the Fitz Hughs, though in 1286–87 Brian Fitz Alan held half a carucate of the earl. The Fitz Hughs at first held Lartington in demesne, and it ultimately returned to them after having been granted to a succession of under-tenants. Some time at the close of the twelfth or beginning of the thirteenth century, Henry, son of Hervey, Lord of Ravensworth, gave to Robert de Lascelles and his heirs the 'whole vill with its demesnes, services and all appurtenances, saving to himself and his heirs hunting rights in the forest; Robert and his family dwelling at Lartington might hunt, but they must send a servant to the door of Cotherstone to notify their intention, so that Henry's forester might accompany them. Moreover, if they were ever impleaded for hunting without the view of the forester they might be cleared by the oath of this servant in Henry's court of Cotherstone'.

Robert de Lascelles was lord in 1208. He, or a successor of the same name, enfeoffed (defined as under the feudal system and to give someone freehold property or land in exchange for their pledged service). Henry Spring of Houghton le Spring, Durham, held the manor in 1291–92. Henry left a son and heir – Humphrey, presumably a minor – for John Spring had a grant of free warren in Lartington in 1301. Humphrey was lord in 1313 and was dead by 1328, leaving a widow, Elizabeth, and sons Henry and John, both underage. Henry's brother, still a minor, had succeeded by 1340. From the Springs the right in Lartington descended by a female heir, Elizabeth, to Henry Headlam. Henry and Elizabeth were in legal possession in 1403, and in 1414 they made a settlement which seems to have been a conveyance to the Fitz Hughs, for in 1427 Elizabeth, widow of Henry Fitz Hugh, died also in legal possession of two parts of the manor, and the Fitz Hughs and their descendants continued to hold Lartington until the death of the Marquess of Northampton in 1571. After this Lartington followed the descent of the manor of Cotherstone until 1639, when William, Earl of Devon, sold it to Francis Appleby. In 1648, Francis Appleby of Lartington begged for a discharge of, or leave to, compound for the estate of his uncle Francis Appleby, who died during his appeal from sequestration, and in 1654 Mary Appleby widow appealed in the same way. Margaret, daughter and sole heir of

Francis Appleby, married Thomas Maire of Hardwick and died in 1672 giving birth to her son Thomas, who succeeded his father in 1685 and himself died in 1752. Francis, eldest son of Thomas, died in his father's lifetime, and he was succeeded by his second son, also Thomas, who in 1762 was succeeded by his brother John. John had no children, and his remaining brother and two sisters died without issue. In 1764, he conveyed his estate to the husband of his sister Anastasia, Sir Henry Lawson of Brough Hall. Sir Henry died childless in 1834, when this manor passed to his sister Katharine, widow of John Silvertop. On her death it descended to her second son, Henry Thomas Maire Lawson, who married Eliza, daughter of Thomas Witham of Headlam, Durham, and niece and heir of William Witham of Cliffe, Yorkshire. Henry subsequently assumed the name of Witham. He died in 1844. His elder sons, Henry and William, had died in his lifetime and he was succeeded by his third son, George, who died unmarried in 1847, and then by his fourth son Revd Monsignor Thomas Edward Witham. This ecclesiastical dignitary died in 1897 and was succeeded by his great-grandnephew Francis Somerled Silvertop of Minster Acres, Northumberland. He sold it in 1912 to Mr M. D. Spence of Shotley Bridge.

The Fitz Hugh's impact on the village and surrounding area cannot be underestimated. In the churchyard of Laithkirk is a memorial to W. R. Bell, who was the Vicar of Laithkirk for thirty-one years, from 1864 to 1895, and who was unfortunately drowned in the River Tees. He was well known in Teesdale, and especially for his study of local history and folklore, which he published using his parish magazine. The magazine was called *The Lord Fitzhugh and His Neighbour, Lord Baliol* to commemorate the feudal lords of Cotherstone and Barnard Castle. Some of these journals remain to this day. In Romaldkirk's church is a fine monument to Hugh Fitz Henry, Lord of Cotherstone and Ravensworth castles and founder of the Fitz Hugh family, who died in 1304 during the Scottish wars in the reign of Edward I. He is buried at Romaldkirk.

There is also 'The Legend of Cotherstone', which is remembered through an old ballad. In 1512, George, 7th Baron Fitz Hugh, was a young man of twenty-five years old. Like many wealthy young men of his day, he was a very keen huntsman. His particular hunting ground was near the village of Cotherstone. The woods and forests here were not densely packed and provided ideal conditions for deer to thrive and therefore were great hunting grounds. George was renowned as an inspiring leader and ferocious warrior, having demonstrated this in battles during wartime; however, domestically he was known for his kindness, courtesy, excellent manners and charm. It was one morning in 1512 when tragedy was to strike. He had set out upon his horse to meet friends for a hunting party when, on his way, he saw an old crippled woman as she stumbled her way along the road. As the baron's horse approached her she raised her stick and called out to him: 'My Lord. I am glad I have met you. I have come to warn you not to go to the hunt this day.' The young baron halted his horse and asked why he shouldn't hunt. The old woman warned of mortal danger to both him and his horse; a danger so grave it would end his family line as he had no children. 'Keep away from Percymyre Crag,' she told him. The young baron politely thanked the old woman for her words of advice and promised her he would avoid the crag by only hunting on the opposite side of the river. The young baron and his friends from Cotherstone had a miserable day hunting. The hounds would pick up a scent then scatter, sending the following riders off in all directions. Then the scent would be lost and the pack would come back together. Time and again this happened throughout the day.

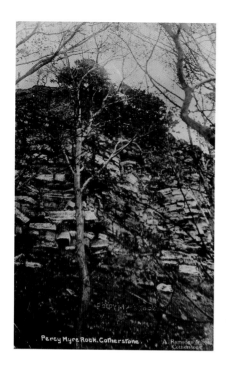

Left: Percy Myre Crag.

Below: Close to Percy Myre Crag today and the sheer drop to the River Tees. (Image courtesy of Richard Laidler, middletonphotos.co.uk)

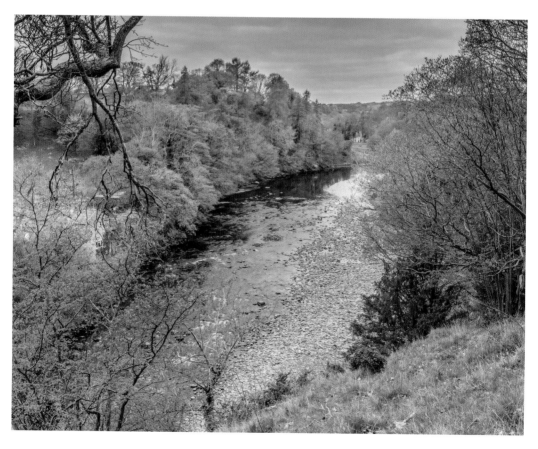

The hounds and riders were just about to return to Cotherstone from their hunting ground when a magnificent stag emerged from the treeline.

The hounds picked up the scent and the chase was on. The baron and his friends followed the hounds as the excitement after a long day of failure built. As the hounds got closer, the stag ran faster. The riders pushed their mounts to keep up with the chase. Desperate to avoid being caught, the stag went into the river to throw the hounds off its scent. The hounds were too close and followed the stag across the water, with the riders hot on their heels. The stag continued to run, leapt up and then disappeared. It had gone over the side of a cliff – Percy Myre Crag. The hounds were unable to stop and also disappeared. Seeing what had happened, the young baron pulled hard on the reigns of his horse, but it was too late. The horse followed the stag and hounds over the edge, taking its rider with it. The old woman's prediction on the road from Cotherstone had come true. This legend is still told to this day.

Cotherstone and nearby Cotherstone Moor remained a quiet rural area, which was not changed, even by the presence of a small lead mine further up Baldersdale, between Balderhead and Blackton reservoirs. A similar lead mine also stood on the Cotherstone Moor, and the remains of hushes and leats can still be seen. However, Cotherstone and the surrounding area was little affected by the impact of lead mining, unlike villages further up Teesdale, including Middleton-in-Teesdale, Newbiggin and Eggleston. A few important industrial relics remain and include the ruins of Balder Mill, which was probably built in the seventeenth or early eighteenth century. Unfortunately, a nearby manor house has now disappeared.

Many of the older houses in Cotherstone were typical stone farmhouses of late seventeenth- or early eighteenth-century date. However, with the arrival of the mines up the dale and the growth of industry further downstream of the Tees, a number of large houses were built in the village by nineteenth-century industrialists. Once the railway arrived in 1868 the village expanded and several rows of terraced houses and larger Victorian and Edwardian houses were constructed. Cotherstone developed as a commuter village and holiday resort, and was nicknamed 'Little Sunderland'. Farmsteads were demolished, cottages rebuilt and many more large villa-type houses were built. Apartments and tea rooms became more popular to cater for the many visitors from the burgeoning towns of the North East region, from Newcastle-upon-Tyne and Sunderland. The needs of these new visitors were met by many local craftsmen and numerous shops within the village.

Another industry, which to this day is still ever present, commenced in the early twentieth century when Cotherstone became increasingly well known for its cheesemaking. Cotherstone cheese is similar to Stilton and may well have been made in the area since the seventeenth century. The most famous maker of Cotherstone cheese was Mrs Katharine Birkett, cheesemaker at West Park until 1940. Cotherstone cheese is still produced in the area to this day, which is discussed later in the book.

In 1870–72, John Marius Wilson's *Imperial Gazetteer of England and Wales* described Cotherstone as:

COTHERSTON, a township in Romaldkirk parish, N.R. Yorkshire; on the river Tees and the Tees Valley branch railway 3¾ miles NW of Barnard-Castle. It contains five hamlets, and has a post office under Darlington and a railway station ... Pop., 561.

Houses, 128. There are chapels for Independents and Primitive Methodists; and ruins of an old castle, which belonged to the Fitz-Hughses.

In 1920, author Allan Ramsden wrote *A Guide to Places of Interest and Beauty Near Cotherstone, Romaldkirk and Egglestone.* It gives a remarkable description of the village at the beginning of the twentieth century. 'The village of Cotherstone is delightfully situated on the south bank of the Tees, four miles N.W. of Barnard Castle, and near the railway station of its own name. The scenery around is beautiful, the air bracing, and the place much frequented as a health resort.' Ramsden is effusive describing it further as:

Simply a gem among the villages in the north of England. For beauty it is unequalled, standing as it does on the banks of the river Tees and Balder. The scenery surrounding it, for miles in extent, is also remarkably fine. No pen and ink description of it could do it justice; it is simply charming; the scenery is of nature's own making. There are no embattled towers; no ancient crypts; no Roman encampments. Nature is found at home, and you see her in all different moods. Nor is she silent, as if her strength were spent. You have the murmuring brook, the gentle rill, the dashing torrent and the robust river. There is no place where voice is not heard.

Further descriptions of the village describe it as 'a favourite resort in the summer season for visitors from Sunderland and Newcastle, the air being considered very healthy and the

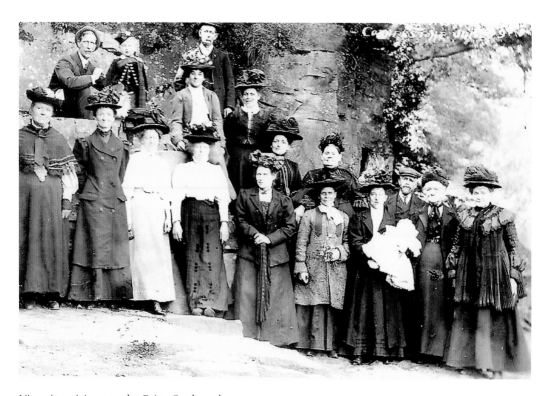

Victorian visitors to the Fairy Cupboards.

locality abounding in walks along the river Tees and up the Balder Vale, the scenery of which is very beautiful'. It was the coming of the railway in 1868 that was to change the village into such a resort and place of popularity.

The Stockton & Darlington Railway opened a line to Barnard Castle in 1856; the line was called the Darlington & Barnard Castle Railway. Barnard Castle received a second station in 1861 when the South Durham & Lancashire Railway built its line to Barras, Westmorland. The two stations were some distance apart, necessitating a long walk. To alleviate this, the second station became a through station on 1 May 1862, and on the same day the original Stockton & Darlington terminus was closed. The whole line and its branches eventually became part of the Stockton & Darlington Railway, which was absorbed into the North Eastern Railway in 1863. There was a proposal to build a line from the Stockton & Darlington at Barnard Castle to Alston, but this was never built in its entirety. Only the southern section of this line was built by the independent Tees Valley Railway, who promoted a branch from Barnard Castle to Middleton-in-Teesdale. With few villages and no towns within the catchment area of the branch it was clear that it would not generate much passenger revenue, so the main attraction of the line was the carriage of mineral deposits, which were found in the locality.

An Act of Parliament was obtained on 19 June 1865 and the 7-mile, single-track line had its public opening on 12 May 1868, with passenger services starting the following day. Initially there were two intermediate stations at Mickleton and Cotherstone. The spelling of the station name was altered to Cotherston on 1 January 1906, reverting back to Cotherstone in April 1914. The station was downgraded to an unstaffed halt on 5 April 1954;

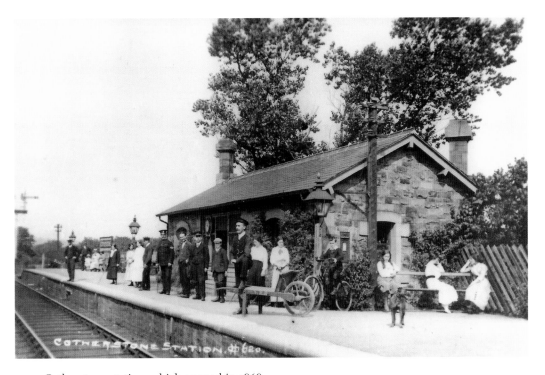

Cotherstone station, which opened in 1868.

freight services ran until 1965 and eventually ceased. A third station at Romaldkirk appears to have opened later as it was not ready in time for the opening, first appearing in the company timetable in July 1868. There were two major engineering features on the line: the Lunedale and Baldersdale viaducts (both of which still stand today). From the outset the line was worked by the North Eastern Railway (NER). The Tees Valley Railway was not financially successful, and the local company was taken over by the North Eastern Railway by an Act of 19 June 1882. The NER agreed to settle the outstanding debts up to £22,000 and to purchase the line for £25,188. The line was then incorporated into the Central Division of the NER. Much of the line's traffic was stone with interchange facilities at Middleton-in-Teesdale station.

The Middleton branch never carried heavy passenger traffic. In 1922, there were five trains a day in each direction on weekdays and one train on Sunday. By 1950 this had increased to six daily trains, but no Sunday service. The engine shed at Middleton was closed in 1957 when the steam service was replaced by diesel multiple units (DMUs), but they were unable to halt the decline in passenger numbers and many trains ran virtually empty.

After the withdrawal of the Barnard Castle to Penrith service on 22 January 1962, through running from Sunderland and Newcastle ceased and all Middleton trains started at Darlington with seven trains daily from Darlington to Barnard Castle, five of which continued to Middleton. The 'Mondays Only' early morning train from Darlington to Middleton, and the 'Saturdays Only' late evening train from Middleton did carry passengers, although their main function was to supply the weekly DMU to Middleton on the Monday and to get it back to Darlington diesel depot on the Saturday.

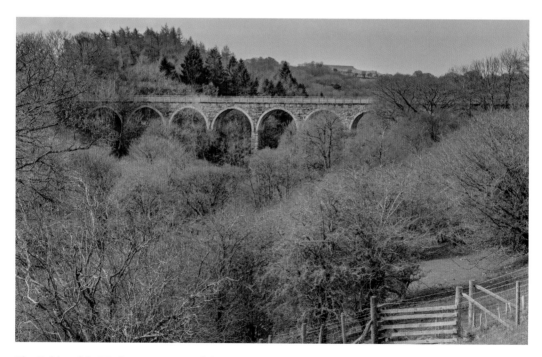

The Baldersdale Viaduct, now part of the Tees Valley Railway Path. (Image courtesy of Richard Laidler, middletonphotos.co.uk)

The line was earmarked for closure as part of the Beeching cuts and the proposal to close was published on 6 December 1963. The formal enquiry was held at Barnard Castle on 27 February 1964 to hear sixty-five objections to the closure, but on 11 September 1964 the Minister of Transport, Ernest Marples, gave his consent, subject to the usual conditions regarding the provision of a modified bus service, with the last passenger train running on Saturday 28 November 1964. Formal closure to passengers was on 30 November. Freight traffic lasted for a few months, being withdrawn from Romaldkirk and Middleton-in-Teesdale on 5 April 1965.

The track had been lifted by May 1967 and today much of the course forms the Tees Valley Railway Path, with a car park at the former Mickleton station site. The path starts near to Lonton, half a mile south-south-east of Middleton-in-Teesdale, and ends near Lartington 2 miles north-north-west of Barnard Castle.

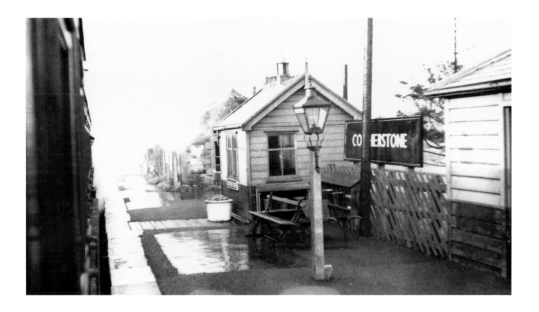

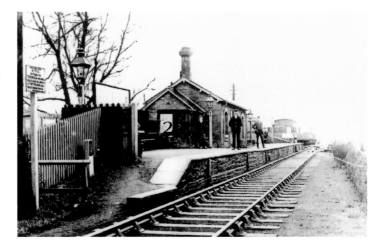

Above: Approaching Cotherstone station.

Right: The single line from Barnard Castle to Middleton-in-Teesdale.

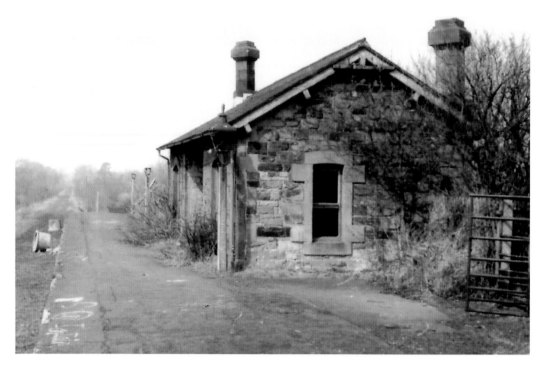

Closure by Beeching, but this was no surprise due to declining usage.

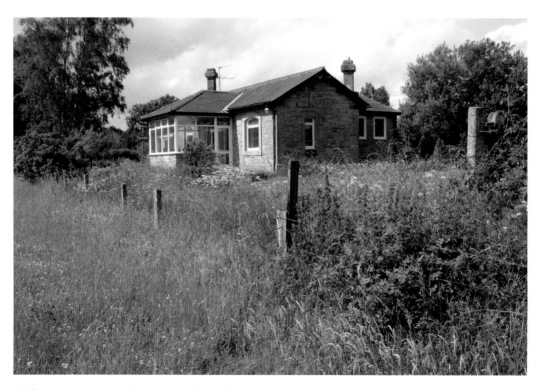

Cotherstone station today, now residential.

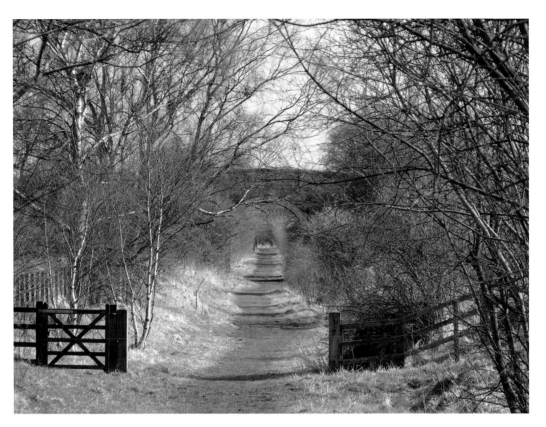

The former railway, now part of the Tees Valley Railway Path.

3

Buildings and Architecture

In 1986, local historian Vera Chapman with the Cotherstone Local History Group produced a booklet called *Cotherstone Village Past and Present: Tradition and Change in the Houses of a Teesdale Village from the 1830s*. Chapman talks of the change that came to Cotherstone as a result of the arrival of the Tees Valley branch railway. Decline of the population was reversed. Where previously the call of the industrial towns of the North East was promising work, the local population increased from a low point of 561 residents in 1861 to a peak of 701 in 1921. The attraction was clean air, the riverside scenery of the Tees and Balder, unaffected here by the lead mining industry of the upper dale. Day trippers and holiday makers flocked here and as a consequence, cafes, apartments and boarding houses sprung up along with the supporting services needed for this growing population. Over a dozen

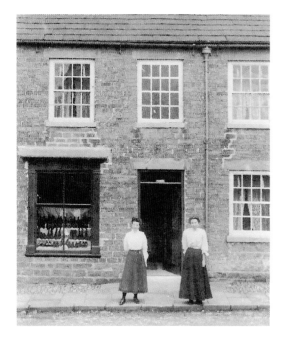

Hillfield, with boots and shoes sold by Alderson's the cobblers.

shops were present along with two boot and shoemakers, two blacksmiths and three carpenters. The Directory of 1840 notes the presence of 'carpet manufactory' of Jacob Allison and Co. in the village and two boarding schools which appear to have closed. Other trades included boot and shoemakers by the name of Stubbs, Raine and Bainbridge; a land surveyor called John Lawson, and a schoolmistress by the name of Margaret Lawson. There were four shopkeepers, three butchers and three tailors present.

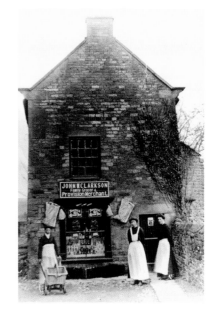

Right: John Clarkson was a provision merchant at Featherstone House. It was a shop until the late 1950s.

Below: Delivery day at the family grocers – now Bag End Cottage.

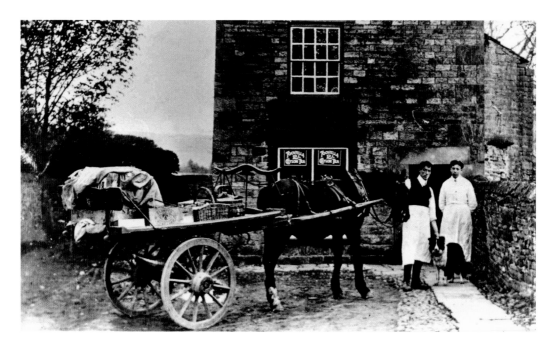

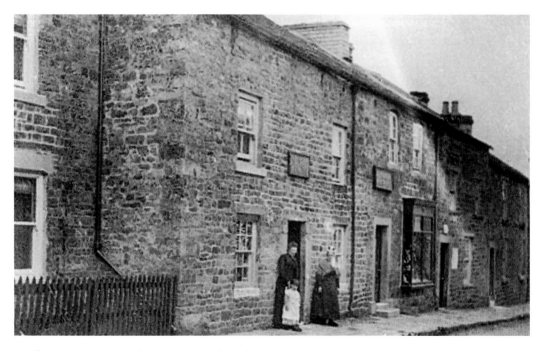

On the main street and there are a number of shops, including Bessie Jewitt's shop at Romney Cottage. In 1890 this was a carters with rooms let out. Lynton, further down the street, was two cottages, with one also being a fruit and vegetable shop.

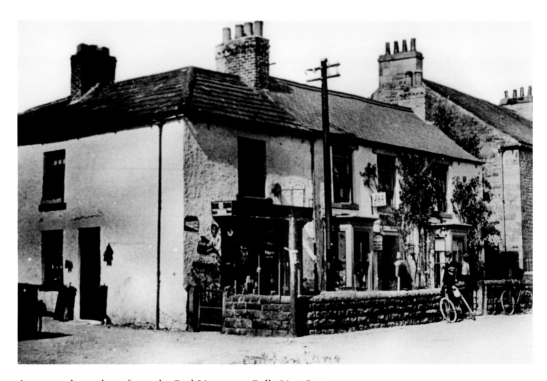

A corner shop, along from the Red Lion, now Belle Vue Cottage.

By 1890, 638 people are living in the 'township of Cotherston', with many trades serving the local population and visitors. These included James Alderson, shoemaker; Thomas Bayles, victualler and farmer at the Red Lion; Miss Annie Henderson, owner of apartments; William Kipling, grocer and steam corn mill proprietor; John Rutter, tailor; Post, Money Order Office and Savings Bank at Thomas Raine's; and Henry Park, stationmaster. By 1893, William Heslop is sub-postmaster, with letters arriving from Darlington by 8:10 a.m. and dispatched by 5:25 p.m. Romaldkirk is the nearest telegraph office. The local parochial school now caters for seventy-five children, but only has an average attendance of fifty, all under the tutorship of Thomas Blenkinsopp.

By 1913, the Directory includes a Burial Board, which consists of eight members responsible for the parishes of Cotherstone and Lartington. A temperance hall (now the village hall) has been built, dating from 1893, with a library, reading room and refreshment rooms and 'a large room suitable for public meetings'. Principal landowners in the area are the Earl of Strathmore and Kinghorne, who is lord of the manor; John Henry Bourne esq.; the trustees of the late Timothy Hutchinson esq. of Egglestone Hall; and David Magnus Spence esq, JP. The population numbers remain stable, growing to 644, and the school can now cater for 110, but the average attendance is still very low at thirty-one.

Commercial premises are numerous, serving the established number of residents and the many visitors from Sunderland and Newcastle. Many buildings are still noted as apartments, including those owned by Miss Annie Henderson, Miss Mary Carlton, Ralph Coulthard, Miss Sophia Hills and Mrs Mary Langton at Heatherlea. Present are also the Teesdale Egg & Dairy Society Ltd, egg merchants, dairymen and poultry breeders, with Thomas Heslop secretary and manager.

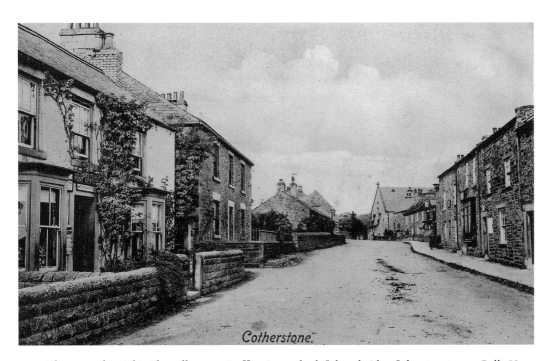

Cotherstone.

Shops on the right. The village post office is on the left-hand side of the street, now Belle Vue.

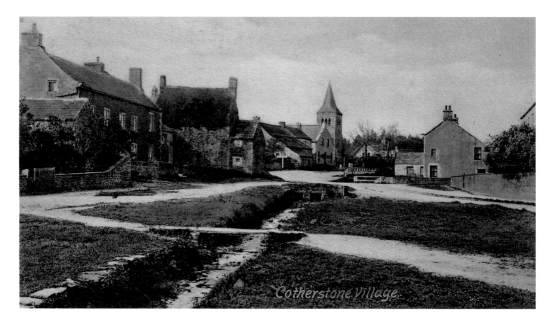

The East Green, with the church in the distance and the adjacent former temperance hall, now the village hall. The Manor House overlooks the green with the heather-thatched building alongside it.

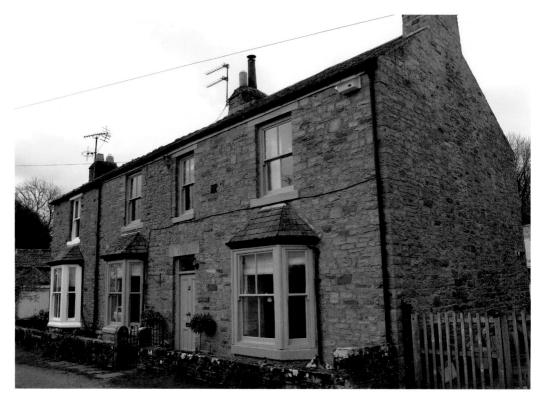

Heatherlea, former apartments, managed by Mary Langton.

By 1921, the population of the village reached a peak of 701. Many of the smaller farmsteads and barns had now been replaced with large villas, terraces and handsome stone residences. Vera Chapman cites among them, Railway, Nicholson and Shipley terraces, along with the fine residences of The Limes, Lancelands, Red Gables, Glen View and Glenside. These all complemented the new community facilities with the building of the Wesleyan chapel in 1872 and day schools in 1874. St Cuthbert's Church was to follow in 1881, with the parochial school in 1894 and the temperance hall in 1893. Many back lanes remain from the heart of the village, from previous farmyards to a complex pattern of long, narrow fields, indicating former field patterns and agricultural practices from a distant medieval time.

In her booklet *Cotherstone Village Past and Present*, Vera Chapman also looked into the architecture of the village in greater detail, and the current authors have reproduced some of this within this book. Her works are now incredibly hard to source but they still remain an important reminder of the village vernacular.

There are many notable old houses that still exist in Cotherstone to this day, despite the many changes of the twentieth and twenty-first centuries. These include the Manor House and Fox Hall, which date from the seventeenth century; the Green, from the eighteenth century; along with Brooklea (Brook House, 1733), The Red Lion (1738), Rose Cottage (1743), Saltoun House, West Lodge and Westrill. There are a few that are reminders of farmsteads – once characteristic of the village street. Lambeth House, Cuthbert Cottage and Gilmour House are fine examples, and each comprise a dwelling with an outbuilding attached, a garth behind and a long, narrow croft to the rear of the back lane leading to scattered fields. Lambeth House was certainly being used for agricultural purposes even

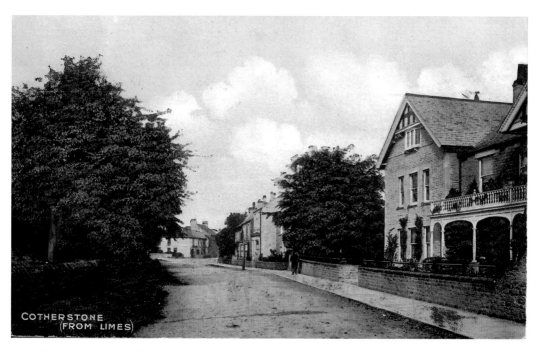

COTHERSTONE
(FROM LIMES)

The Limes, originally thatched and eventually apartments.

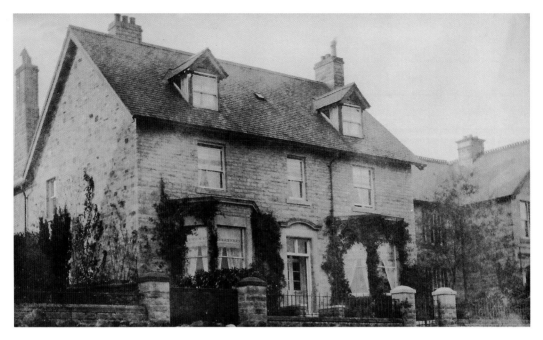

Glenside, on the Briscoe Road, today a large dwelling house but once apartments.

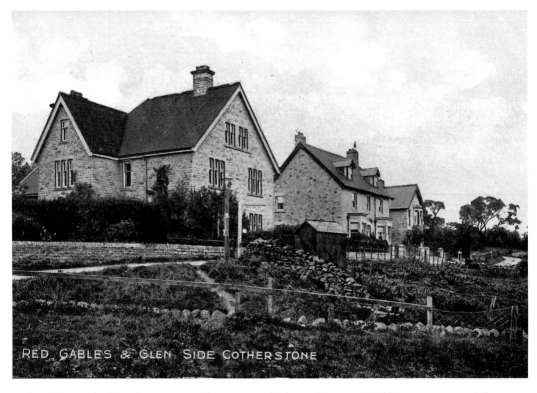

Red Gables and Glenside, imposing houses overlooking the River Balder, once catered for visitors from Sunderland and Newcastle.

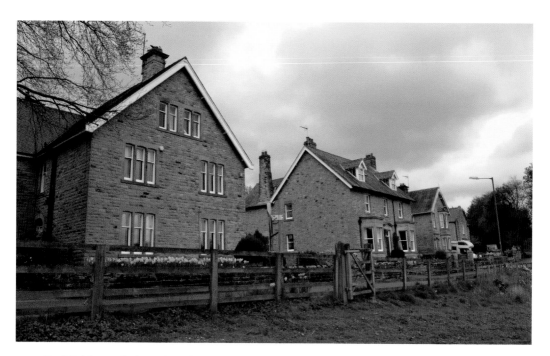

Red Gables and Glenside today.

as late as 2021, although the house itself remains unoccupied. Cuthbert Cottage, set back from the main road, is generally remembered by older village residents as Ye Tea House, a local café and bakery with a rather odd black kettle hanging sign that says 'to vent steam and attract customers'.

Other remaining older buildings include Manor House, which dates from the early 1600s, with many alterations in the eighteenth century and an extension added in the twentieth century. Fox Hall was built in the late 1600s but was extended in 1747. It eventually became a shop, remaining as such until 1985 when it was further restored. It is

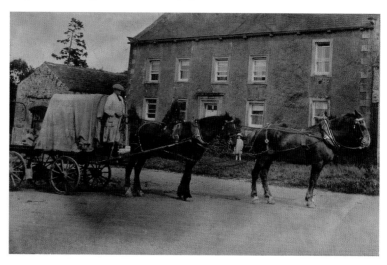

The Manor House, dating from the seventeenth century.

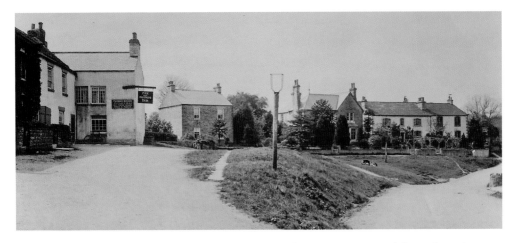

The West Green, showing the Fox and Hounds and Saltoun House, second from the right.

now residential. Moor Cottage is thick-walled and has a low ceiling. The building at the rear is the original and the front was added in 1805. Brooklea was built in 1753, and eventually increased in size in 1953. One of the most imposing buildings in the village is The Limes, which is characteristic by having two gable-fronted wings and a fashionable verandah. Rokell was once a coach house and a stable. Craig Lea is likely to have developed from, or even replaced, a barn. Chapel House, simply by its name, gives its previous use away and was once the congregational chapel, built in 1869.

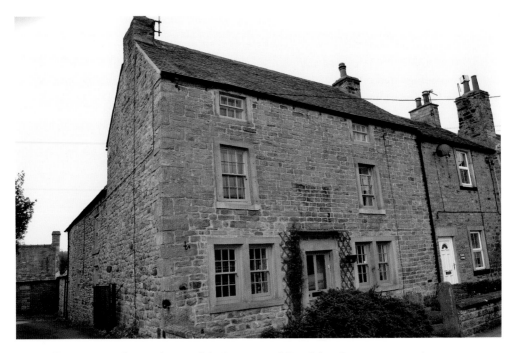

Fox Hall, once G. Hodgson, the People's Grocery and Provision Store.

Many of these earlier buildings from around the eighteenth century or earlier were usually one room deep. They were often enlarged to the rear with a 'teefall'. The definition of this was difficult to source, but it is apparently 'a shed or building annexed to the wall of a larger one, having its roof formed in a single slope with the top resting against the wall; a lean-to'. Other extensions included an outshut (where a smaller, lower addition is added to a building; the new roof makes one continuous roof with the main roof, and is often at a shallower pitch to the main roof) with a long, sloping roof, allowing space for a scullery, dairy and stair. Since the Second World War, many of these 'teefalls' gained a bathroom and bedroom simply by raising the roof. Many of these older buildings have been modernised and have lost such features as cottage doors and sideways-sliding Yorkshire sash windows.

Building materials were sourced locally and this is reflected in the local vernacular. Local stone was readily available, and villagers with rights to the common could bring stone from the moor for their own buildings and for repairs and maintenance. Grit and sandstone rubble was used for basic walling and was either coursed or uncoursed. The frontages of many of the houses were given greater detail and the quality of material was higher. Cut stone slabs were needed for lintels, jambs and quoins. Local quarries supplied such stone and included Shipley Quarries to the north of the River Tees, which provided high-quality freestone that was delivered over the Tees ford to the Hagg. Such stone was used to build Shipley Terrace and the Methodist chapel. Chapman describes the use of such materials: 'Stone flag roofs are heavy, and in time might sag at the ridge. A large flag weighs 35lbs and more, substantial overlapping is necessary. So flags were graduated from large and thick at the eaves to small and thin at the ridge, itself lapped with shaped stone sections. Sheep shank bones or wooden pegs fastened the flags. The roof pitch is low, about 30 degrees.' In a

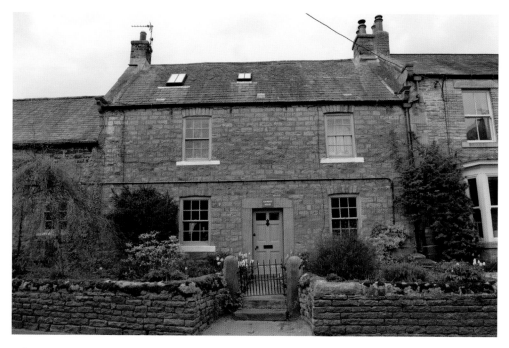

Gilmour House.

number of instances, the gable walls project above the roof, indicating possible previous thatching. These gable walls are capped with flat stones resting at the building corners on kneelers, which as Chapman points out are 'a structural feature whose decorative treatment relieves the plain, sturdy vernacular tradition of Teesdale'. Gilmour House offers a fine example of such detailing.

Very early picture postcards also indicate that a number of the older buildings in the village were thatched with heather from Cotherstone Moor. This was known as 'black thatch' due to its very dark colour, in contrast to the thatched cottages of the West Country and Home Counties. The village was once described by a young man in an article in *The Teesdale Mercury* as 'all thatch', who was of the opinion that 'there could not be a more dreary spot on earth'. Such thatching continued in the village as late as the 1930s, but by this time was less common. The Kiplings of Baldersdale were local commercial thatchers, although local farmers managed to thatch small byres or outbuildings themselves. According to Chapman, 'heather sufficiently long, but not too old or brittle, was gathered and tied into bundles or threaves. These were opened out and spread in rows on the roof from the eaves upwards, each row pegged with spelks, bent hazel twigs sharpened at each end.'

The roofs of these buildings were steep and the thatch nestled between high-swept eaves as a protection from strong winds lifting the roofs off. They rested on a row of flags, which also kept water from percolating through the walls. Within the houses the thatch was 'ceiled off', but in the many outbuildings it was visible from the inside, supported by rafters of roughly trimmed branches or small tree trunks, which were crossed at the apex to take the ridge pole or rigg. The heather swelled in wet weather and therefore all gaps were closed, sealing the roof.

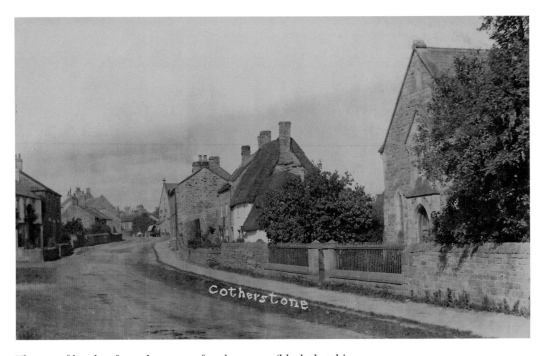

The use of heather from the moor, often known as 'black thatch'.

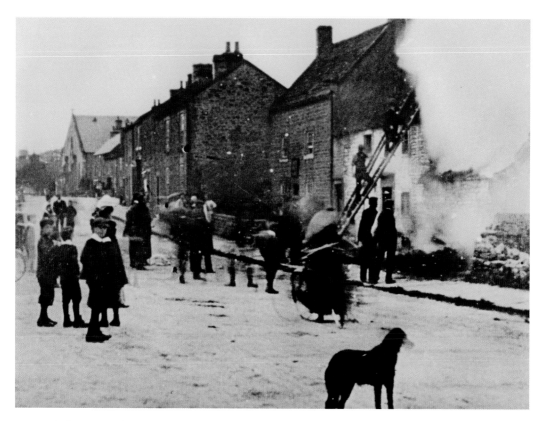

The burning of the cottage in 1912.

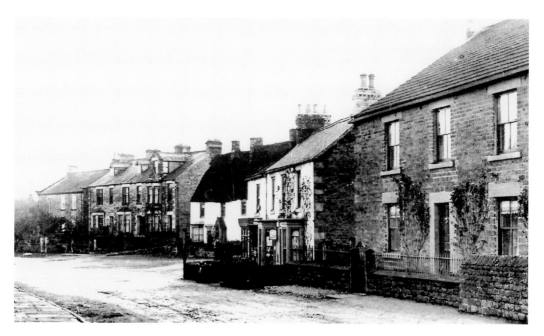

The Red Lion, the last building in the village to retain 'black thatch'.

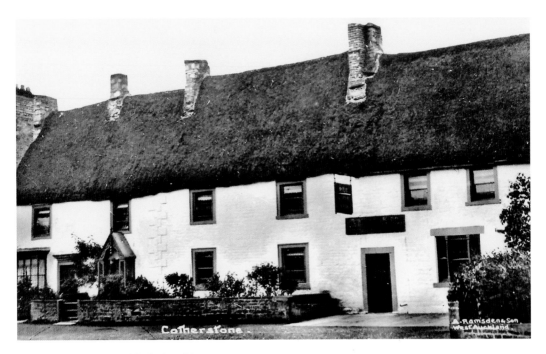

The Red Lion and its 'black thatch'.

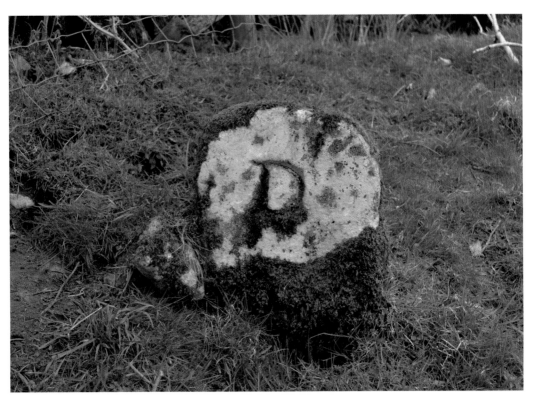

The Duke of Devonshire boundary stone on the periphery of the village, marked by a 'D'.

Thatched buildings were ideal for controlling the temperature, being cool in summer and warm in winter. Fire, however, was a serious hazard, as was the case with the cottage next to the former petrol station, which has 'MH 1725' on its doorway lintel. This was previously heather thatched but burnt down in 1912. Old images of Brooklea show a thatched roof, as does the Red Lion, which was the last building to retain its thatch, until the 1930s. Its steep roof, with its pitch of 50–60 degrees, gives a clue to its previous roofing material, as does the former byre beside Gilmour House. Buildings that were stone flagged had a much lower pitch when they replaced thatching, and opportunities were often taken at the time to add in upper rooms, raising many to two storeys in height with small windows in the gable end.

Returning to the first half of the nineteenth century, much of the village was owned by the Duke of Devonshire, well before the railways arrived. By 1833, the duke decided to sell his Cotherstone estate. This included sixteen properties along the village street and consisted primarily of stone-built farms, smallholdings, houses and cottages. Unfortunately, about half of these have now disappeared and many have been altered, but a number remain intact. At the time he wished to sell his properties only three were thatched, with most slated with sandstone flags. Cumbrian and Welsh slate became more readily available with the arrival of the railways.

As described in 1833, the following were included in the sales particulars:

The East Side of the Village

Chapel Cottage	Quick Garth, a nursery held by Moses Allason.
Pensbury	A very neat dwelling house, stone built and slated, containing four rooms. A lean-to, barn, cow-house, poultry house and piggery, held by John Bowron.
Littlegarth	A cottage and a small parcel of meadow land with a garden, yard, and cow-houses thereon, stone built and thatched, held by John Helmer.
The Limes	A dwelling house, stone built and thatched, containing parlour, kitchen, back kitchen, coal house, dairy and two bedrooms; a cow-house, cart house and calf pens. A garden. Held by John Chapellow.
Croft House	A stone-built farmhouse with slated roof, containing four bedrooms, and a large garret over, two parlours, kitchen, dairy and a lean-to wash-house. The outbuildings comprise a stable, a range of buildings containing a cart shed, a carpenter's workshops, cow-house, barn, another cow-house, and open cattle shed, all stone built and slated. Held by Edward Walton.
Methodist chapel	A cottage and garden, held by Caleb Wilson.
Shipley Terrace	The Garth, meadow held by Jane Simpson. Barn and meadow land held by Atkinson Lambert.
Balder View, Dale View and Pound House	Cottage, garden, paddock and meadow, occupied by Jane Simpson.

Westrill	A convenient dwelling house, built of stone and slated, containing a parlour, good kitchen, dairy and pantry – two bedrooms over. A cow-house for four cows and loft over, and a coal house. Held by Jane Simpson.
Grey Stones and Terrace House	A stone-built farmhouse with a slated roof, containing kitchen, parlour, dairy, back kitchen and room over, three bedrooms and a small ditto. Adjoining is a stable, tiled. A fold yard with cow-house for eight cows, turnip house and open cattle sheds, a detached barn, stone built and slated, and straw house adjoining; a lean-to cart house, tiled. A stable for four horses, and loft over, cart shed and calf house, garden and piggeries at the rear of the farmhouse. Occupied by Atkinson Lambert.
Lambeth House	A cottage, stone built and slated, containing kitchen, bedroom and dairy. A stable and cow-house. Held by Robert Davis.
Cuthbert Cottage	A dwelling house containing kitchen, two bedrooms, pantry and back wash house. A stable, cow-house, coal place and a piggery. Held by Alice Kipling.
Gilmour House	A dwelling house containing parlour, kitchen, dairy and two chambers. A wood house, hay house, two cow-houses. Held by Jane Bowron.
Craig Lea	Yard and garden, held by Caleb Wilson.
Poplar Cottage	A dwelling house constructed of stone and thatched, containing two rooms, dairy and pantry, a bedroom over, and a dark room, a barn, cow-house, stable and cart house, all built of stone and thatched. Held by John Hildreth.
Brookside and Cotherstone County Primary School	A stone-built dwelling house, slated, containing two rooms, back kitchen, dairy and two bedrooms. A stable, cow-house, potato house and piggery and a rich parcel of pastureland. Held by John Parkin.

In the two years after Queen Victoria came to the throne (1837) the village was resurveyed for the assessment of tithe payments. The tithe award is an important record of the time as it recorded the owners and occupiers of the buildings and land after the sale by the Duke of Devonshire, with a short description of each property that was surveyed and identified on a plan. The changes in ownership were considerable, as by this time the duke only owned one property on the village street, which became the site of the eventual Methodist chapel. He still retained ownership of the pinfold for impounding stray stock, which was situated close to the current Rose Cottage. The tithe return only refers to one shop present, which

Lambeth House.

was to change many years later as previously referred to. However, a carpet manufactory is listed, still owned by Jacob Allison and located by Balder Bridge, along with two carpenter's shops, a timber yard, two blacksmiths, two pubs, a beer shop and three chapels for Quaker, Wesleyan and Protestant denominations.

A number of other directories from the 1800s give detailed descriptions of the village. Baines' directory of 1832 describes Cotherstone:

> Pleasantly situated upon the banks of the Tees, near which is the remains of a castle, once the property of the Fitzhugh family, now in the possession of Mr. Hutchinson of Hall Garth Hill.
>
> Here are three chapels for divine worship, one for each belonging to the Independents, Methodists and Society of Friends; likewise two boarding schools, chiefly occupied by boarders from London. Also a free school for twenty-five poor children, supported by Mr. Charles Waistell, a gentleman of London. Population 706.

Jacob Allison is referred to as a 'stuff manufacturer' and John Chapelow as having a 'dying mill'. Also present are three gentlewomen, three schoolmasters, a surgeon and an independent minister, with tradespeople including two butchers, two shopkeepers and three shoemakers. Only fifteen farmers are listed, and these are mainly outside the village by now. White's directory of 1840 gives little further information, but does mention:

> [The village] has 631 souls and about 8,000 acres of land, mostly a hilly moorland tract, including the scattered hamlets of Briscoe, Naby, Corn Park, Louphouse and

Hall Garth Hill House. The door lintel is formerly inscribed 'J.H. 1778' – John Hutchinson. The square sundial above, in moulded surround with bracketed sill, iron gnomon and ball finial, is inscribed 'I.A. 1774' – John Askew.

Towler Hill, and in two manors, one freehold, one freehold, of which the Duke of Devonshire is lord, and the other copyhold, of which J. Bowes Esq. is lord ... The village has a carpet manufactory, and had two large boarding schools, which were continued some years ago. Cotherstone is noted for the manufacture of cheese, of the same form and quality as Stilton cheese.

Also listed are 'two victuallers kept the Fox and the Lion and Temperance Hotel, and James Johnson had a beerhouse and blacksmith's'.

In Vera Chapman's booklet, there is a section that refers to Cotherstone Academy. Reference has already been made to schools in the village. There were, in fact, two boarding schools for young gentlemen in the village environs, and these were closed in the 1830s. John Smith was listed as 'schoolmaster' in 1832, but by 1840 he was listed as a 'gentleman'. Smith's school was no 'walk in the park' and was run on strict terms. A prospectus for John Smith's Academy of 1830 and associated letter, which was posted to the Countess of Portsmouth in 1912, describes life at the school. It was 'one of those schools which was satirized by Charles Dickens in Nicholas Nickleby as Dotheboys Hall ... this one of Smith's at Cotherstone was very badly conducted and the boys half starved. My uncle has seen them taking turnips from a field to satisfy their hunger.' The *Teesdale Mercury* in 1934 has a feature by F. E. Coates that stated:

In 1827 James Abernethy, afterwards known as a reputable engineer, was a scholar of Smith's School; he was not happy there, and was rescued by his uncle. This school had been founded by Adam Thwaite in 1812, and fell under the Dickensism and a victim of the Press reporters of the time. It was a tradition then that the building had been formerly a nunnery ... Another school was that of George Chapman, where 80 scholars lived as one family at a cost of 20 to 24 guineas a year.

These were tough times. Chapman is unclear of exactly where these schools were located in the village. It is possible that Saltoun House/West Lodge was a school, as well as a large house previously on the site of Nicholson Terrace. Both were sizeable properties. The tithe survey indicates a George Chapman, who occupied either Laburnum or Brunton Cottage in 1838. These were certainly not big enough for a boarding school. Alan Lee, writing in his *Short Guide to Romaldkirk* lists the burials of five pupils from the school run by Adam Thwaite in Cotherstone between 1805 and 1812. Two of these were aged eight and nine with another described as a 'lad'. One of these pupils came from Kent and another from London.

One school that was nearby that we know more of was the academy at Woden Croft Lodge. When Edward Simpson opened a dale boarding school for boys it was not long before he attracted the sons of affluent families living in the South. This was hardly surprising as his adverts made out that his academy at Woden Croft Lodge, near Cotherstone, was a seat of learning of the highest order. He built the first section in 1792 and added more as the demand for places grew. One notice in *The Times* promised that young gentlemen would be instructed in English, Greek and Latin languages; writing; arithmetic; merchants' accounts; and the most useful branches of mathematics. There was an entrance fee of a half guinea. Annual fees were then 16 guineas for four to eight year olds, 20 guineas for ages nine to twelve and 25 guineas for older lads. There were extra lessons in mechanics, drawing and French for additional money. It added: 'The health and morals of Mr Simpson's pupils are strictly attended to, and in order to expedite their education as much as possible he does not allow any vacation, but innocent recreations out of school hours are permitted and encouraged.' The lack of holidays would no doubt appeal to some wealthy parents who simply wanted rid of their offspring without the nuisance of them arriving home for an occasional break.

The 'recreation' wasn't much fun because they had to work in surrounding fields, which were run as a farm holding. There were reports of some looking unkempt and almost bootless, like spiritless drudges, as they carried out menial tasks. They probably feared Simpson at times because a verse that summed him up went:

> A man severe he was and stern to view
> Well had the boding tremblers learned to trace
> The day's disasters in his morning face
> Full well they laughed with counterfeit glee
> At all his jokes for many a joke had he
> Full well the busy whispers circling round
> conveyed the dismal tidings when he frowned.

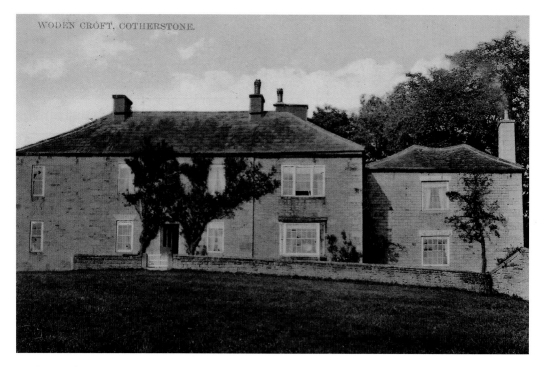

Woden Croft, once a school of strict discipline.

Several boys died at the school. A gravestone to one read: 'In memory of Richard Higgenden Watkins of Ramsgate, who departed this life on the 4th day of April 1810 at Woden Croft Lodge aged 7 years 9 months and 4 days.' Known as Neddy, Simpson was thirty-eight years old when he started the school, and he ran it for nearly thirty years. One pupil wrote later that there were about 150 boys there. They had to crowd round a trough to wash in summer or winter. There were no towels, so they had to dry themselves on their clothes. They were often given brimstone and treacle with a chunk of bread for breakfast. Other meals were poor, but if they did not eat them they could be thrashed. Sometimes three, four or even five boys had to sleep in one bed. Simpson was in London trying to sign up more pupils when he died in 1821 at the age of sixty-seven. His son, Lionel, took over the school. Also, according to Murray's Handbook (1890) Richard Cobden (1804–65) was a pupil here. Cobden was an English radical and liberal politician, manufacturer and a campaigner for free trade and peace, and was closely associated with the Anti-Corn Law League. The Woden Croft buildings are a private residence today.

At the beginning of the chapter, Chapman refers to the incoming visitors to Cotherstone from the industrial towns of the North East, with the village being known as 'Little Sunderland' in the first half of the twentieth century. *The Sunderland Daily Echo* of 7 October 1903 has a feature on 'Cotherstone as a Health Resort' from 'a correspondent':

Cotherstone is rapidly growing in popularity and each year the number of visitors is increasing, proving that it is quite a favourite Yorkshire village ... with lovely scenery and in the very heart of the Tees Valley which all go to remind you of a bit of the Rhine

'The health and morals of Mr Simpson's pupils are strictly attended to, and in order to expedite their education as much as possible he does not allow any vacation, but innocent recreations out of school hours are permitted and encouraged.'

in miniature. One of the greatest attractions which it holds out to visitors is its very extensive moors many miles in extent and its dry bracing air. Numbers of invalids take advantage of these health giving properties so greatly recommended by most of our eminent medical men. Numbers of people suffering from medical affections, consumption and liver complaints are cured by this dry, bracing, and pure air.

There is plenty of good fishing and many beautiful walks, which are all free to visitors, which is a great boon and recommendation. Cotherstone has, too, an excellent railway service in summer, it being the first station from Barnard Castle. It possesses a pretty little church and two chapels. There are two good old fashioned inns and over the door of one is 'Red Lion, date 1737'. A bit of advice inside is worth noting and is rather amusing. It appears on a sign as follows, 'Call frequently, drink moderately, buy honourably, be good company, part friendly, go home quietly' ... there are numerous lovely drives from Cotherstone, and anyone wishing for a month's summer holiday could not do better than pay Cotherstone a visit.

Nearly thirty years later, *The Sunderland Echo and Shipping Gazette* of 1 July 1932 is advertising LNER trips to Cotherstone from Penshaw, Washington and Fencehouses. The same publication dated 3 August 1934 is advertising LNER trips from Sunderland and East Boldon. After the Second World War, the village was to significantly decline in numbers,

Summer visitors to the village in the 1930s.

eventually exacerbated by the closure of the railway line in 1964, thanks to Dr Beeching. Decline, though, had set in though many years earlier. *The Sunderland Echo* of 13 July 1950 ran a headline 'Pied Piper of Cotherstone'.

> This is Cotherstone – picture postcard village of long summer days and sweet smelling hay, where so many Wearsiders go to live in retirement or on holiday that it has been called Sunderland in Teesdale ... but it is also the village of few children ... for a twentieth century version of the Pied Piper of Hamelin in the guise of prosperity and industry has robbed Cotherstone's sandstone cottages and grey-slated houses of the sound of children's laughter and baby squeakings. The population of the village was declining with families moving in the other direction to the industrial towns of the north-east. In 1950, only 24 children remained in the village. School numbers had dwindled to sixty with only twenty from the village itself, the remaining from outlying area. This sleepy little village of 115 houses ... where three grocers and general dealers supply most of the residents' needs, is waiting for something.

Change was coming. Many buildings remain from the time it was known as a holiday resort and its wider connections with Sunderland. Most of these have been restored and are lived in by families who have since moved to the village.

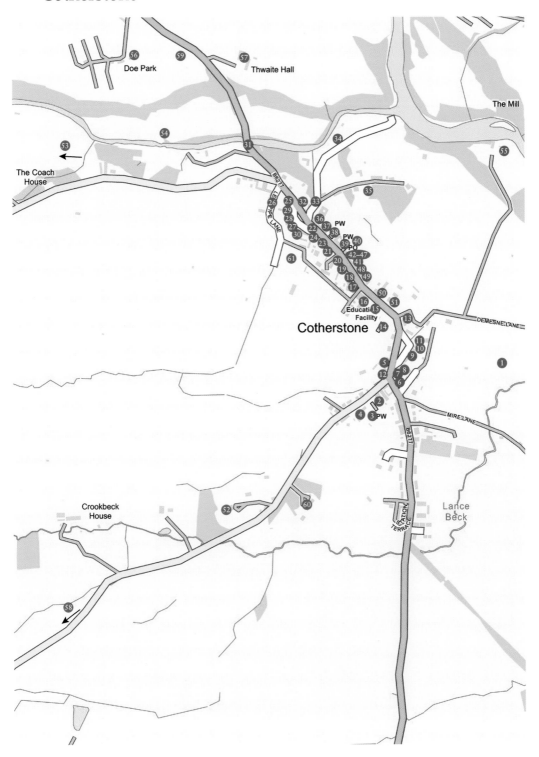

Doe Park

Thwaite Hall

The Mill

The Coach House

Cotherstone

Educati Facility

DEMESNE LANE

MIRE LANE

STATION TERRACE

Lance Beck

Crookbeck House

1. The Friends' Meeting House

In *North-Country Lore and Legend*, in February 1891, Cotherstone is quoted as being known for Quakers and formerly used to be inhabited almost entirely by members of the Society of Friends, but in 1891 the village consists of a 'goodly number of Cotherstonites [who] are adherents of that sect', and included the Andrews family who lived at Hallgarth, up the Hagg.

Today, the Friends' Meeting House in Cotherstone is located in a field to the east of the main village. The meeting house was built in 1797 and is still an active place of worship for the Teesdale & Cleveland Area Meeting (Quakers). It is a Grade II listed building on the National Heritage List for England. It is of specific interest as it is a Quaker meeting house that typifies the modest nature of these buildings for worship, and which retains its essential historic form and character from the time of its construction. It has an unusual elders' stand and other historic fabric, which is preserved in the interior and provides evidence for the division of space and internal arrangements typical for earlier Quaker meeting houses. It remains substantially intact as a purpose-built, late eighteenth-century Friends' Meeting House that speaks to the strength of Quakerism locally during that century.

The Quaker movement emerged out of a period of religious and political turmoil in the mid-seventeenth century. Its main protagonist, George Fox, openly rejected traditional religious doctrine, instead promoting the theory that all people could have a direct relationship with God, without dependence on sermonising ministers, nor the necessity of consecrated places of worship. Fox, originally from Leicestershire, claimed the Holy Spirit was within each person, and from 1647 travelled the country as an itinerant preacher. The year 1652 was pivotal in his campaign; after a vision on Pendle Hill, Lancashire, Fox was moved to visit Firbank Fell, Cumbria, where he delivered a rousing, three-hour speech to an assembly of 1,000 people, and recruited numerous converts. The Quakers, formally named the Religious Society of Friends, was thus established. Fox visited Cotherstone in 1653.

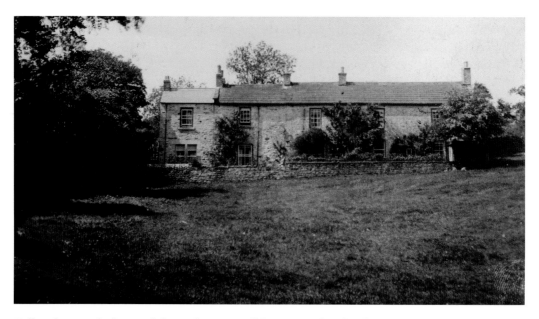

Hallgarth, once the home of the Andrews, a well-known Quaker family.

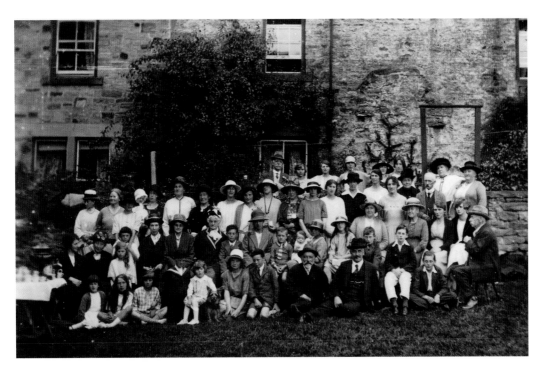

An Andrews family gathering.

Quaker meeting houses, like we have here in Cotherstone, are generally characterised by simplicity of design, both externally and internally, reflecting the form of worship they were designed to accommodate. The earliest purpose-built meeting houses were built by local craftsmen following regional traditions and were on a domestic scale, frequently resembling vernacular houses; at the same time, a number of older buildings were converted to Quaker use. From the first, most meeting houses shared certain characteristics, containing a well-lit meeting hall with a simple arrangement of seating. In time a raised stand became common behind the bench for the elders, so that travelling ministers could be better heard. Where possible, a meeting house would provide separate accommodation for the women's business meetings, and early meeting houses may retain a timber screen, allowing the separation (and combination) of spaces for business and worship. In general, the meeting house will have little or no decoration or enrichment, with joinery frequently left unpainted. Ancillary buildings erected in addition to a meeting house could include stabling and covered spaces such as a gig house, caretaker's accommodation, or a schoolroom or adult school.

Quaker meetings have been held at Cotherstone from the 1680s. During the eighteenth century, the farming community was characterised as 'all cheese and Quakers' due to the high proportion of Quakers living there. Cotherstone's meeting house stands in a burial ground and replaced a nearby Lartington meeting house. The first grave here was of a boy of African descent from nearby Wodencroft School. The south-facing porch was added in 1837, when the interior may also have been refitted, including the current partition dividing the meeting house into two rooms. A single-storey cloakroom was added to the

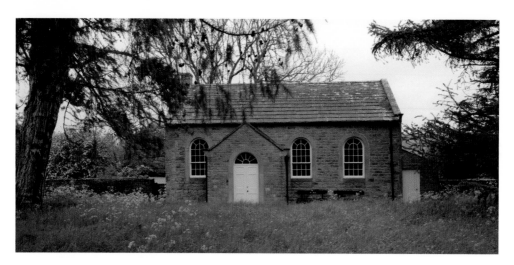

The Friends' Meeting House.

south and east sides in 1857 but was demolished in 1987. At that time the building was refurbished, a window opening in the west wall was built up and the porch's flat roof was replaced with a pitched roof. Allan Ramsden describes the meeting house in 1921 as 'quaint, calm and reposeful, in cloak of ivy dressed, rests in peace sublime, accompanied by a quiet graveyard, where sleep the worshippers of other days, awaiting the final day of earth's great drama'. Very poetic, and it really has not changed over the last 100 years.

2. The Village Hall

The village hall in Cotherstone was originally built in 1893 as a temperance hall with a library, reading and refreshment rooms, along with a large room suitable for public meetings. It has been modernised for its use as a village hall over many years. It has a large hall, two meeting rooms and a kitchen. Today, the village hall is a registered charity and is managed by volunteers.

The village hall, once a temperance hall and still the hub of the community.

3. St Cuthbert's Church

At the heart of the village and on Moor Road is the church of St Cuthbert, a chapel of ease to Romaldkirk, and was erected in 1881, funded by a gift and efforts of a visitor to Cotherstone 'for health reasons'. With its foundation stone laid by R. A. Morritt of Rokeby, it is a building of local stone in the Early English style, consisting of chancel, nave and a western tower containing a clock and six bells, presented by Jonathan Pearson esq. of Notting Hill, London, in memory of his mother, who died in 1872. The clock, put up in 1885, was purchased out of money left by Anthony Benjamin Nicholson esq. of Cotherstone. The church's architect was from London and called Caspar Purdon Clarke, with the construction carried out by local builders Messrs Kyle of Barnard Castle. Born in 1846, Purdon Clarke was the second son of Edward Marmaduke Clarke and Mary Agnes Close. He was educated at Gaultier's School in Sydenham, Kent, and Beaucourt's School in Boulogne, France. Between 1862 and 1865 he studied architecture at the National Art Training Schools at South Kensington. In 1865, he entered the office of works where he distinguished himself in work for the rebuilding of the Houses of Parliament. In 1866, he married Frances Susannah Collins, with whom he had eight children – three sons and five daughters. The eldest son, C. Stanley Clarke, became assistant keeper of the Indian section of the Victoria and Albert Museum.

The church spire, which replaced a small 'pepper pot' spirelet, came several years later and is described in *The Bell News* on 18 October 1913: 'The new spire of St. Cutbert's [*sic*] Church, Cotherstone, Co. Durham, is nearing completion. The spire was designed by and has been erected under the supervision of Messrs, Clark and Moscrop, architects of Darlington, The contractor is Mr. R. Wilson of Barnard Castle.'

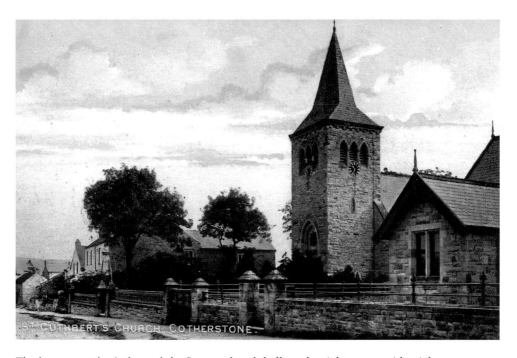

The 'pepper pot' spirelet and the former church hall on the right, now residential.

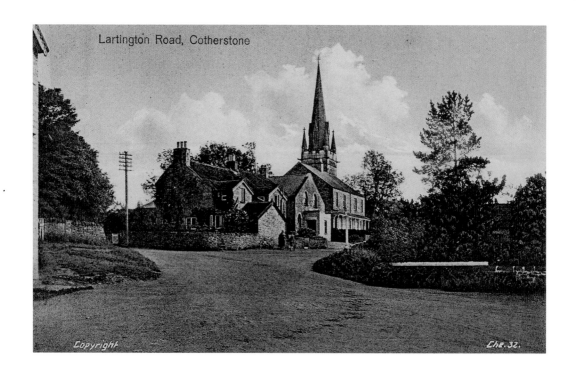

Lartington Road, Cotherstone

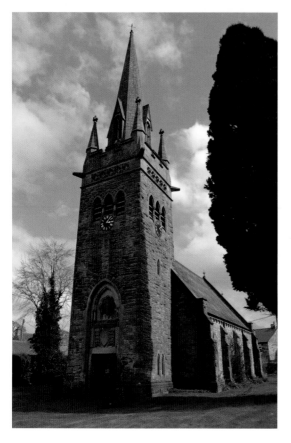

Above: The new spire, erected in 1913.

Left: St Cuthbert's Church today.

The spire, resplendent among autumn colours.

4. The Church Hall

Also on Moor Road is the church hall, not to be confused with the nearby village hall. This was built in 1894 as the parochial school for 110 children. It is noted for its inscription on the front, which states *'In Te Domine Speravi'* – 'In Thee Lord will I Trust'. It was endowed with land by John Bourne, from an ancient local family, to provide income and funding for sixteen free places.

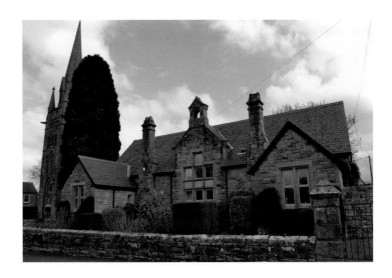

The former church hall.

5. Former Blacksmith's Shop

Now raised to two storeys, there were once three blacksmith shops in the village – a reminder of its agricultural past.

6. Chapel Cottage

This was once a primitive Methodist chapel, with a front entrance, porch and steps. When it was converted a number of old mourning cards were discovered.

7. Spring Bank House

The gabled front was once Willie Clarkson's butcher's shop, now residential.

8. The Manor House (East Green)

This is probably the oldest inhabited house in the village, most likely the site of an earlier house and once part of the ancient property of the Bourne family from medieval times. The oldest parts of this building are early seventeenth century and incorporate earlier timbers. Over the years, improvements have been made, including during the early eighteenth century. The door surround dates from 1720 and the building is also noted for its grooved stone surrounds. To the right-hand side of the building is a later extension. There are also reputed underground passages from the former dairy leading in the direction of the castle. The building was also known as Mount Pleasant Farm, with outbuildings to the rear.

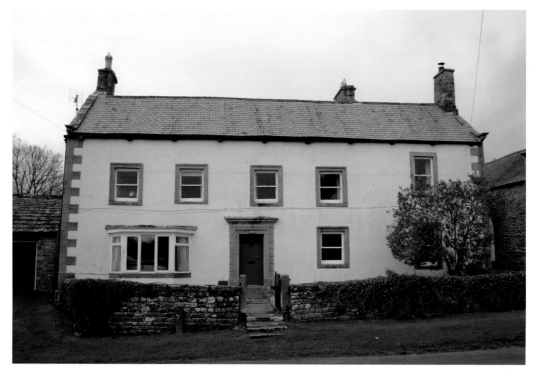

The Manor House.

9. Three Cottages (East Green)

These were probably built in the eighteenth or early nineteenth centuries, as Mount Pleasant farmworkers and are now listed.

10. The Green (East Green)

This magnificent house also has links to the Bourne family and is early nineteenth century. The interior is reputedly similar to the Manor House further up the green and is also Grade II listed.

The Green, one of the grandest houses in the village.

11. Rokell Cottage (East Green)

This was converted in the 1950s and was the previous coach house and stables for the Green. The arch of the coach house is still visible.

12. Brook House

Noted for its lintel dated 1733 and once the home of the Allison family. Certainly, this was also thatched, and extended in 1953. It is also listed.

13. Featherstone House

Once a general shop until about 1958, with a warehouse to the rear.

14. Cotherstone County Primary School

An infant and primary school, this was opened in 1964 and designed by county architect R. Allport Williams and built by Hoggett & Son from Barnard Castle. The younger Rabbitts

(author) has many happy memories of attending this school under the tutorship of Mrs Baum, Miss Kearton, Mrs Sewell and Mrs Gauja.

15. The Poplars

Another fine house in the village with stone window surrounds in a variety of styles. This is yet another reminder of the previous popularity of the village as a holiday resort as it was once an apartment house in the 1920s.

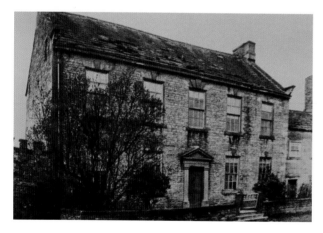

Above: The Poplars.

Left: The original five-bay Georgian house was demolished to make way for Nicholson Terrace.

16. Nicholson Terrace

The terrace was built on the site of a five-bay Georgian House, which was once a boarding school ('one of the worst sort') and later a house owned by Anthony Nicholson. It was eventually demolished and replaced by the present nineteenth-century terrace, with date stones incorporated at the side – 1775 and 1682.

58

17. The Red Lion Public House

This was the last heather-thatched building in the village with its last known re-thatching in the 1920s. Today it is Grade II listed. Its stone-flagged roof dating from the 1930s retains the steep pitch typical of a former thatched property. There were four bedrooms for visitors and was stabling for eight horses, with a horse-tethering ring still present in the front wall. It remains a popular village public house.

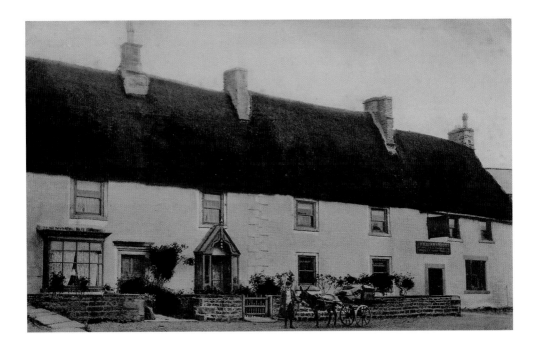

Above: The Red Lion Hotel, thatched until at least the 1920s.

Right: The Red Lion and Nicholson Terrace.

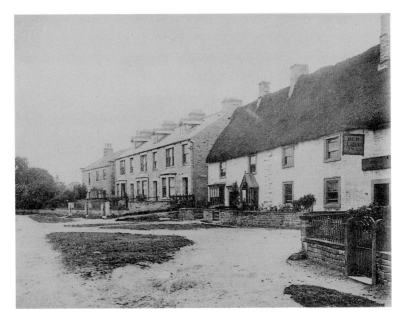

A quiet scene on the main street of the village.

18. Belle Vue

Once Heslop's post office, grocer and general store, chemist and a druggist, as well as a newsagent and 'circulating' library. The shop door was across the corner of the building with two rectangular shop windows protruding. Today they are two cottages.

19. Cotherstone House

A house dating from the nineteenth century and was also a former boarding house.

20. Craig Lea

This was once a 'cottage, house and garden' and Gill's butcher's shop. Old Mrs Gill attended the Hill School on Hallgarth Hill Lane in the 1890s, paying 6d per day.

21. Gilmour House

The Blue Welsh slate of the byre and its steep pitch indicate a previously thatched roof. The house itself has strong quoins, which Chapman suggests is an indication it was rebuilt at some time. The curved window heads are an unusual feature and not typical of local vernacular.

22. Lambeth House

One of the rare buildings in the village that has retained its agricultural use as a farm, with stone coping and kneelers at the eaves. The rear area retains many buildings of agricultural use, including a byre. One interesting feature is the Shap granite boulder in the wall footing which is a relic of the Stainmore glacier.

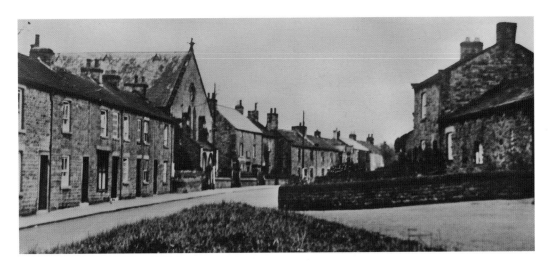

The former Methodist chapel. Lambeth House is on the opposite corner.

23. Fern House
A nineteenth-century house. This replaced Belle Vue as the post office until the 1960s.

24. Cuthbert Cottage
This was once a farm and for many years a bakery and café, Ye Tea House, with its unusual kettle from its hanging sign and a spherical black kettle with steam emerging from its spout, which acted as a flue from the bakery gas oven. It was also a post office at some stage.

Cuthbert Cottage, once Ye Tea House.

25. Fox and Hounds
Still present in the village and dating from at least the early nineteenth century. It had a mounting stone and tethering ring and was the venue for many village functions prior to the village hall being built on Moor Road. The former arch gave access to rear stables.

Above left: Leadpipe Lane.

Above right: Cotherstone village pump, restored by David Rabbitts in 2009.

26. Leadpipe Lane

Leading off the back lane, close to the rear of the Fox and Hounds, is a rural lane known locally as 'Leadpipe Lane'. One theory is that lead was brought this way to and from the smelt mill at Eggleston via the Hagg and Tees ford. The name may also refer to an alleged pipe leading water from the beck to the pump on West Green, used until the 1930s, also feeding the water trough below at the bottom of the Green. The pump on its restoration in 2009, though, was found to have its water source 8–10 feet underground.

27. Claremont and Clare Cottage

Formerly known as The Terrace and most likely dates from the eighteenth century. Claremont was a café between the First and Second world wars.

28. Greystones

This is a very fine house built of ashlar stone and replaced a village farm.

29. Saltoun House and West Lodge

Saltoun House overlooks the West Green and is formerly a Wesleyan school and chapel, built probably in the late eighteenth century having been re-fronted in *c.* 1830. The building is two storeys with a basement, three wide bays and very fine ornamental chimney pots. It was owned by the trustees of the Wesleyan Meeting. One of the finest houses in the village,

Saltoun House is reached by a stone stair above raised half-cellars. It was once known as Briardale and, before that, Prospect House. Chapman has questioned whether this house was Charles Waistell's school for twenty-five children. She also questions whether this was also once the site of Stable Barn Chapel in Cotherstone, opened in 1777 by John Wesley.

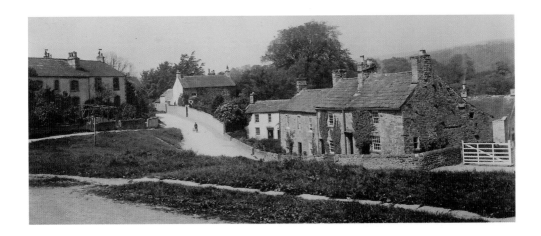

Above: The West Green with Saltoun House on the far left.

Right: Saltoun House in full bloom.

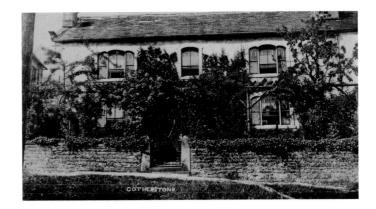

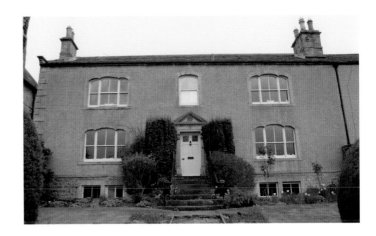

Saltoun House today.

30. Westrill
This has also been reputed to have been a former Methodist chapel.

31. The Balder Bridge
The gateway to the upper dale, this bridge is Grade II listed and was a medieval bridge, rebuilt in 1681. It is a four-ribbed bridge with a pointed arch and was widened on the upstream side in 1896 with two extra ribs. It has been strengthened a number of times as traffic becomes busier on the dales road to Upper Teesdale.

32. Row of Cottages at the West End, north side
These were built on the site of a beer shop, blacksmith shop and former cottages.

33. Hagg Lane
The Hagg is one of the most unusual features of the village. Shaped like an amphitheatre, this land was once common pasture, with a pinfold, or pound, for impounding stray cattle and sheep. 'Hagg' means 'land cleared of trees and brushwood'. The land is now used for sport and recreation.

34. Hagg House and Walled Garden
This was once a one-storey cottage and reputedly the home of a woman poacher who dressed as a ghost when on prowl at night. A house was added onto the gable end around 1900

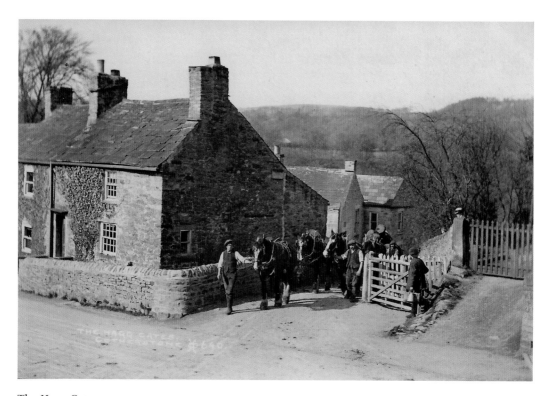

The Hagg Gates.

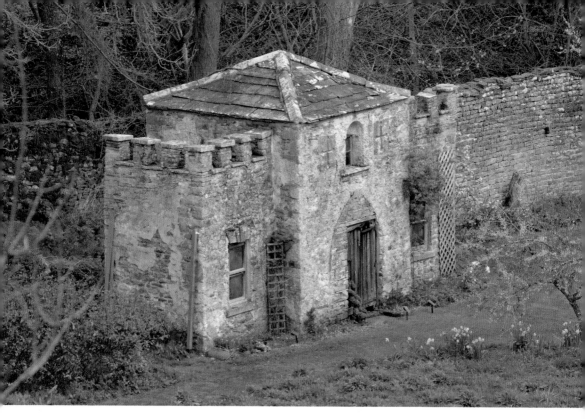

The Gothic folly known as Monks House.

and the cottage was eventually raised to full height around 1950. The walled fruit garden is also of interest, with apple and peach trees. The wall incorporates two Gothic arches which are possible remnants of an ancient chapel whose foundations appear to underlie Chapel Garth, on the hill above the Hagg. Also found in the garden is a nineteenth-century Gothic folly used once as a summerhouse and known locally as 'Monks House'. It is similar to the one in the grounds of Woden Croft.

35. Old Hill School and Chapel
This prominent house was once a Protestant chapel and school before St Cuthbert's Church and the Wesleyan day school were built. It was built around 1785.

36. Shipley Terrace
This fine late nineteenth-century terrace was built on the site of a carpenter's shop, sawpit and byre. Built of stone from the nearby Shipley quarries, each front garden used to have a prominent monkey puzzle tree within, but all have since been removed.

37. South View and Holmdale House
South View was once a bread and cake shop and a haberdasher with an excellent trade in elastic apparently. Holmdale House was occupied by Robinson's boot and shoemaker's shop, but also included an apartment house, reached by separate stairs.

38. Former Methodist Chapel

A plaque dated 1872 was carved by the builder Thomas Waite. Stone from Shipley Quarries was also used here. Behind the former chapel was the Methodist Day School, which opened in 1874 and was later enlarged as the village grew. It was used as a 'through' school for children up to the age of fifteen years of age until the 1960s. It was here that co-author and long-term village resident David Rabbitts spent his educational years.

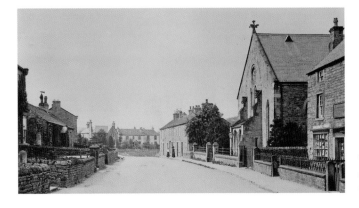

The former Methodist chapel, with Fox Hall to the right.

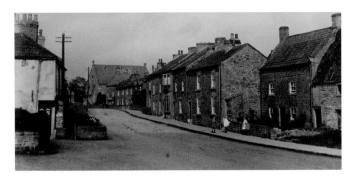

The main street with the Methodist chapel in the distance.

Cotherstone Methodist School, who were taking part in a Dutch song and dance in the village Temperance Institute. Left to right: Jane Crombie, Brian Farnell, Elizabeth Gill, Leonard Thwaites, Irene Scott and David Rabbitts. (*Northern Echo*, Friday 27 March 1953)

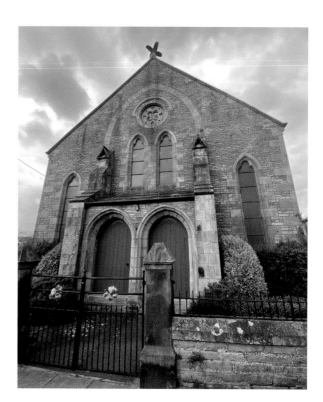

The former chapel today, subject to a proposal to become a new community-run facility in the village.

39. Fox Hall

Fox Hall was allegedly named after George Fox, Quaker preacher. He was reported to give his sermons on the top floor, which was one large room. This double-fronted, three-storey building dates from 1747, but its frontage is likely to be even older. To the left-hand side was William Hodgson's grocer's shop, which sold a vast variety of goods, from fire shovels to syrup on tap – you had to bring your own jar though. Behind Fox Hall was a carpenter's repair shop, with a number of tools from here now in the Bowes Museum in Barnard Castle. Fox Hall ceased to be a shop in 1964.

40. Former Post Office and Village Shop

In the nineteenth century this was a cottage and a carpenter's shop, but by the 1920s and 1930s it had become a grocer's. Outbuildings at the rear included a steam corn mill, warehouse and stable, with a cobbled yard. One of these outbuildings was also a fruiterer.

41. Belmont

For many years this was a well-loved tea shop, 'Ye Tea Shop', and popular because of its teacakes.

42. Moor Cottage

The property dates from 1784 with the frontage being a later addition, added in 1805. This building was used as a bank branch office for two hours on Fridays.

43. Romney Cottage
Yet another business was located here for at least seventy years, up until the Second World War. It was a grocer's and general dealer's shop, occupied by Jewitt's and then Haygarth's. A Shap granite glacial boulder is also incorporated into the building.

44. Hillfield
For over two generations this was occupied by Alderson's boot and shoe shop, with shoe repairs done in the rear garden workshop.

45. Melrose Cottage
In the 1890s this was a carter's business, with the occupier's wife letting out apartments.

46. Lynton
This was once two cottages. To the left was a fruit and vegetable shop, which later became a chimney sweep's part-time business. On the right-hand side, Porch Cottage was the living quarters and was entered from the side porch, which lapped over the next door house's garden.

47. Weatherby House
One of the other houses in the village that was heather thatched. Tyreman's joiner business occupied the premises. Noteworthy are the pantiles over lower rows of stone flags, a style of roofing that is quite unusual for so high up the dale.

48. Former Garage, Petrol Station and Shop
This was extended in 1963 and was the business of Kelvin and Sylvia Walker, and eventually closed in the late 1990s. Very few of the dale's villages now have petrol stations, with nearby Romaldkirk's pumps long since disappeared. A heather-thatched house and byre was once located here but burnt down in 1912.

Not just a village garage, but Kelvin Walker also sold and rented radios and televisions.

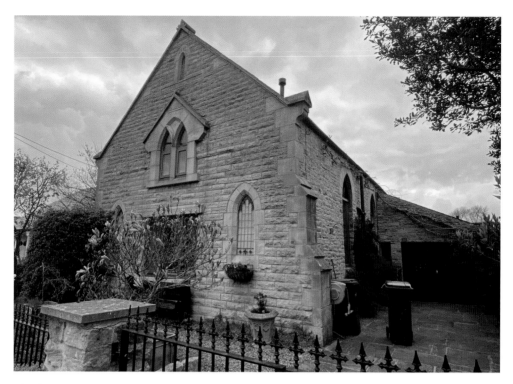

The former Congregational chapel, now residential.

49. Chapel Villa
Now a residence, this was built as a Congregational chapel in 1869 for a society that was founded in 1748. It was an impressive building and seated 160 and was in use as a chapel up until 1940. It was then used as a garage and a warehouse for a local haulage company before being converted to a dwelling.

50. Croft House
Now an agricultural contractor's business, it was once a farmhouse with outbuildings and a timberyard to the rear.

51. The Limes
One of the most prominent buildings in the village is The Limes, opposite the current school. It is a late Victorian house with verandah and eight bedrooms. It was enlarged and remodelled around 1890. Looking closely at the building, the central part of the house appears older from that of the gable-fronted wings, with different stonework used. The grounds of the house were equally grand and included a fruit garden, fernery, heated greenhouse, grotto and tunnel leading to further gardens. Before he built Lancelands (see below), The Limes was the home of Ernest Lingford, a Cotherstone Quaker, and second generation of the well-known firm Joseph Lingford & Son. Their factory was in Bishop Auckland and made baking powder, cornflour, custard powder, ground rice, dried egg, dried milk and liver salts. Lingford's pioneered the forty-hour week and 'Music while you Work'.

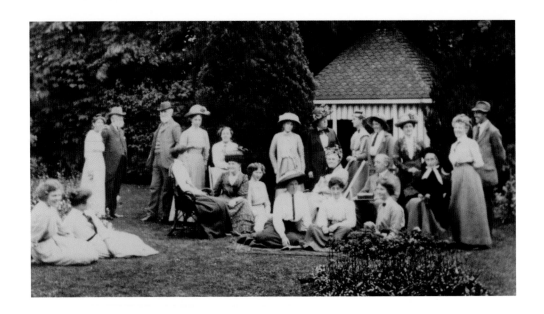

Above: A garden party at The Limes, *c.* 1900.

Left: An affluent couple sat outside The Limes on the main street.

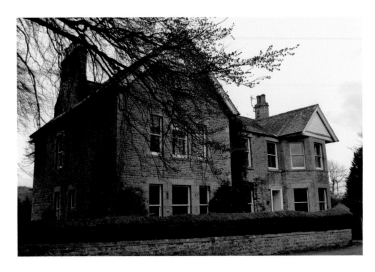

The Limes today.

52. Lancelands

Lancelands is one of the stateliest houses in the village and was designed by architect L. Sutton Wood, with his design for the house exhibited at the Royal Academy Exhibition in 1910. At the doorway to the house is an entrance lodge, also built around 1910 in the simple Arts and Crafts style. It is listed with features including traditional leaded windows, a door with a moulded surround as well as false pigeon holes in the central gable. The occupants of Lancelands were the Lingfords. Herbert Lingford was born in Bishop Auckland in 1891. His father, Ernest, was the second-generation owner of the family provisions supplier business and manufacturer of Lingford's Baking Powder. In 1910 the family moved to Lancelands, Cotherstone, their newly built country house. They are recorded there in the 1911 census, with the number of rooms stated as ten. Herbert is described as a student of law, although this may be inaccurate as he is later said to have an MSc in chemistry. After university he joined the family firm. In September 1915, Herbert married Dorothea Saville, the daughter of a local Baptist minister, and in July 1916 their son Kenneth was born. When conscription was introduced, Herbert appealed as a conscientious objector and his case was heard at a military tribunal at Startforth on 21 June 1916. He was granted exemption from combatant service, conditional on joining the Friends' ambulance unit. He trained at Jordans camp, Buckinghamshire, and was then sent to Uffculme Hospital, Birmingham. This centre had been the home of Richard Cadbury, a famous Quaker, and from 1916 was used to look after disabled ex-servicemen.

Herbert also served abroad and the *Teesdale Mercury* of 13 September 1916 carried a report of him sailing to Salonica in Greece (now Thessalonika). This was in the *Glenart Castle*, a well-equipped hospital ship with 460 beds, ferrying casualties and those suffering from malaria between Greece and Malta. This is confirmed by the record of his service for the Victory and British War medals.

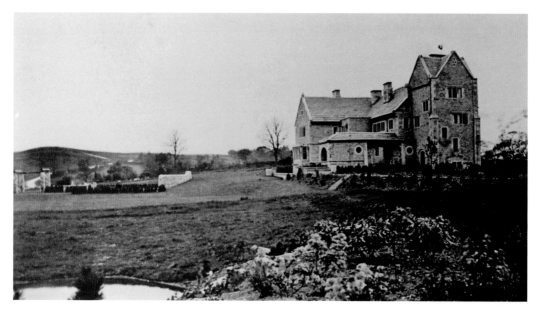

Lancelands, and in the distance is Cotherstone Moor.

Herbert left the ship in September 1916 and returned to service at Jordans and Uffculme. On 26 February 1918, despite being lit up at night as was required of hospital ships, she was sunk by a torpedo from the U-boat UC-56. Sinking in a short space of time and with most lifeboats damaged by the blast, only thirty-two survivors were found. 162 personnel had perished, including most of the crew, eight nurses and seven medical officers, along with ninety-nine of their patients.

Herbert was demobilised in February 1919 and was awarded the British War and Victory medals. Returning to his life in Cotherstone, he was a well-liked employer and a report in the *Teesdale Mercury* of 14 July 1937 described a works outing that he had arranged. In the 1939 register he is recorded as an air-raid precautions warden. In 1950, Herbert Lingford's body was found in Flatts Wood in mysterious circumstances. His death was reported in the *Teesdale Mercury* of 26 April as accidental. He was fulsomely praised as 'a leader among the Friends, a scholar, a naturalist, a Justice of the Peace in Durham and the North Riding, a man of true dignity in all his ways'. However, when the inquest was reported on 17 May the verdict was suicide in an unknown mental state. Herbert was buried in Cotherstone's Quaker burial ground, but the only family headstone remaining is that of his son, Kenneth, who died in 1992.

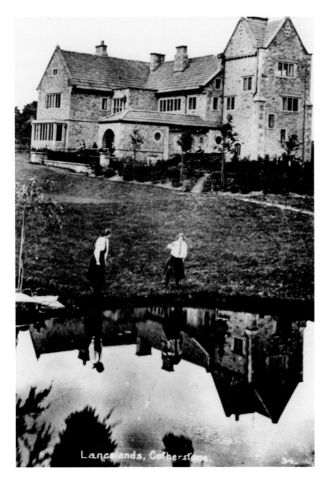

Lancelands, Cotherstone

The Arts and Crafts style of Lancelands.

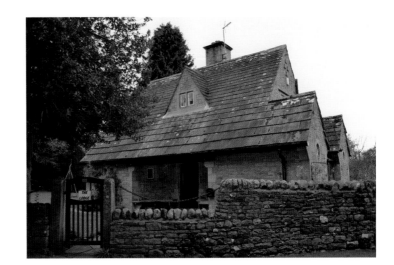

Right: The main cottage, built in a similar style to Lancelands.

Below: Lancelands today.

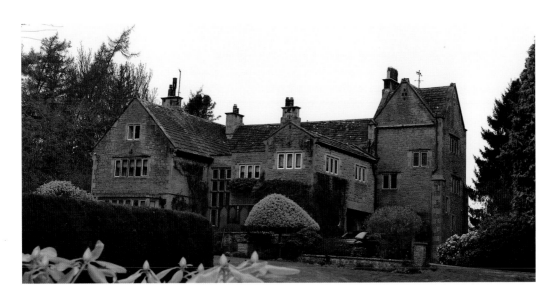

53. Balder Grange

'Went by railway from Darlington to Stockton by steam – 56 minutes – then down to Middlesbro'; inspected the clay as to a scheme for the establishment of a pottery, then walked thro' the town, much increased in two years.' These words were written by Francis Gibson in his diary on 2 November 1833. It was describing 'a magnificent project planned or an immense harbour off Redcar'.

Although this 'magnificent project' never left the drawing board, Gibson was entitled to be proud of much else that he saw – it was being financed with his money. He came from a brewing and banking family from Saffron Walden, Essex. His connections to the great industrial enterprises taking place in Durham and Cleveland in the 1820s and 1830s were religion and marriage. He was, of course, a Quaker, and on 7 May 1829 he married Elizabeth, the youngest daughter of Edward 'Father of the Railways' Pease. He called it

'*dies beatissima*' – the most beautiful day – but to the Peases it must also have been a most attractive arrangement. Gibson was quickly inducted as a director of the Stockton & Darlington Railway (S&DR), and a little later in the same year he was one of four Quakers that Joseph Pease – Edward's son and so Elizabeth's brother – asked to contribute to the £30,000 cost of buying 520 acres of salt marsh. Francis agreed, and so became one of the founders of Middlesbrough.

It was his money rather than his expertise that the Peases seem to have wanted. Even in 1847 – a time of deep economic recession throughout Europe – Francis was providing 'financial assistance' to Joseph and Henry Pease, who found themselves on the brink of bankruptcy. Gibson appears to have been quite happy with being a sleeping partner. On 21 December 1833, he wrote in his diary: 'Received a letter from Mr Coates requesting an answer to my becoming a shareholder in Middlesbro' pottery, a scheme of theirs. If the other proprietors join, I will not desert them, if not I decline, but at the same time should not object to advance £100 or £200 to any responsible persons to enable them to become subscribers.' Middlesbrough Pottery was formed the following year – the first business to open in the new town.

Francis and Elizabeth spent most of their time in Saffron Walden but holidayed in Durham for a couple of months every late summer. In fact, Francis was very taken with the area. 'To Barnard Castle,' he wrote on 15 April 1834. 'Walked by Lartington to Cotherstone. Luxuriant pastures. Tees banks majestic. Fine distances up and down the bends of the Tees at Fairy Cupboards. As fine a river scene as I remember. Thro Romaldkirk to Middleton-in-Teesdale to lodge.' He liked it so much that he bought a place there – Balder Grange – in 1843. Set high above the Tees near its confluence with the Balder, he enlarged an existing house to make a country mansion, indulging in his hobby of landscaping to lay out the gardens. 'None can visit his Balder Grange without appreciating the judgement that selected its site or admire its perfect whole,' said his obituary in the *Darlington and Stockton Times*.

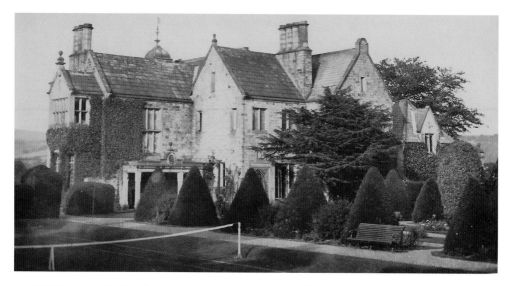

An idyllic scene: Balder Grange in the 1890s. Francis Gibson bought it in 1843 and enlarged the existing house to make a country mansion, where he indulged in his hobby of landscaping. The picture shows part of Gibson's gardens.

Francis was never very healthy. He suffered from asthma most of his life and died, aged fifty-three, on 19 December 1858 in Saffron Walden. 'Prostrated by successive attacks of paralysis, he was aware that the "undeniable messenger on the pale horse" was before the door and he died as he had lived in the full confession and comfort of his Christian faith,' said the *Darlington and Stockton Times*. Two years later, his only son, also Francis, died at the age of thirty of apoplexy in Florence, Italy. His daughter, Elizabeth Pease Gibson, made it to her fortieth birthday, dying in Bristol in 1870.

In 1865, his wife, Elizabeth, made her last trip to Balder Grange before she died in 1866. She wrote tenderly in her diary:

> Once more in this lovely spot, the beloved of those inexpressively dear to me. Perhaps never more than here have I longed to have my departed ones by side and that my precious husband's eyes would once more dwell on the scenes he so admired and on the works of his own uncommon taste, which time has perfected. Dearest Frank! How I think of him in the lovely hours he must have spent here.

Balder Grange is still a lovely spot today, and was eventually owned by the Boothroyd family of Bishop Auckland. It was bought in 1958 by Trevor Boothroyd, whose father, Alfred, had been a clockmaker in Reeth but who moved to Bishop Auckland in 1907 to set up as an optician. The Boothroyds lived here for many years until it was eventually sold in 2021. Just below Balder Grange is the cottage, currently occupied by Richard and Daphne Boothroyd. For eighteen years it was also the home of David Rabbitts, who moved here in 1946 from Zeals in the county of Wiltshire.

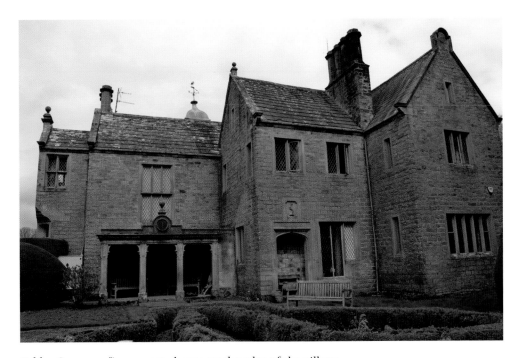

Balder Grange, a fine country house on the edge of the village.

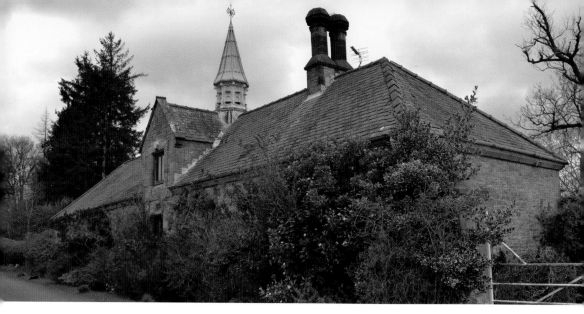

Balder Grange Cottage.

54. Balder Mill

One of the many former watermills in Teesdale is found on the River Balder, just below Doe Park. Many of these were corn mills, but a number were also fulling mills and paper mills. These mills were important part of village life, up until the railways came and made the import of flour possible. The mill here is incredibly picturesque and what remains stands on the north side of the river, just upstream from Balder Bridge. The river descends rapidly over a number of rock outcrops, allowing a stone-lined leat to be led over the adjacent

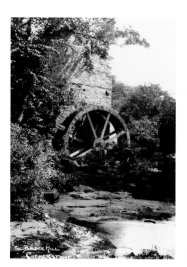
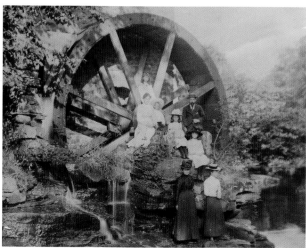

Above left: A picturesque scene on the River Balder and the old mill.

Above right: A gathering by the scenic Balder Mill.

pasture to drop water onto the wheel at a high breast-shot or pitch-back position. This was deemed a more efficient use of water power than overshot or undershot wheels. The mill went out of use at the turn of the twentieth century, with the miller's house behind eventually becoming ruined.

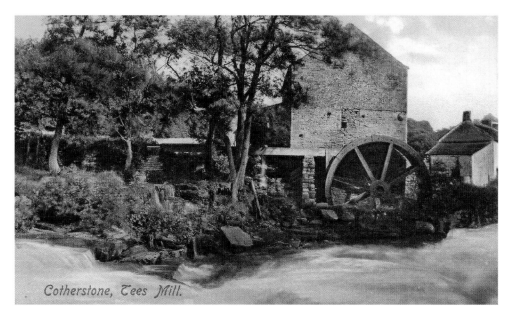

Balder Mill, not Tees Mill as the postcard states.

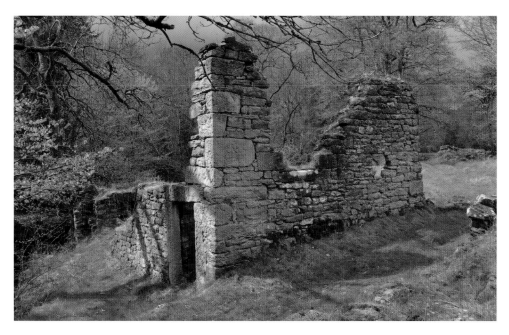

Balder Mill remains today.

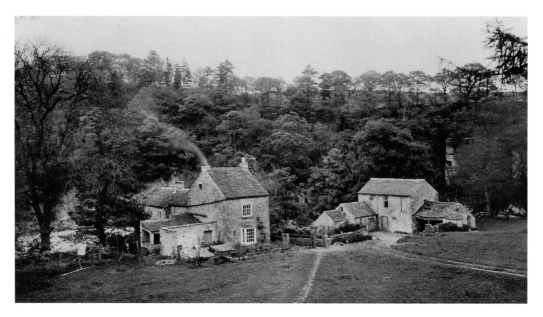

Tees Mill, an early view.

55. Tees Mill

Further downstream from the Balder confluence is Tees Mill, now converted into a house. A weir was set obliquely across the Tees, directing water into the corn mill at the water's edge behind the house. The mill is likely to have ceased production in the 1890s, and converted into a cottage around 1897. The flat land adjacent to the former mill also known as The Holme was once a tennis court where members of the Hounam family once played. The Hounams lived for a time at Cherry Tree Cottage, which bordered the main street. George Hounam served fifty-four years at Backhouse's Bank in Sunderland and was its manager in the 1890s. In the village, William Kipling, in 1890, had a grocer's shop on the main street, which had a steam corn mill behind it that was present through the 1920s and into the 1930s.

56. Doe Park

Just outside the village is a magnificent house known as Doe Park. It is thought that the house and surrounding land were once part of a much larger estate. The earliest record of Doe Park is from 1520 when it was owned by the Craddocks, a family with Royalist connections during the English Civil War. It was almost certainly used as a hunting lodge, but no records remain of what the house was like at that time. Park walls are still apparent in many places. A will of 'John Cradock' of Baldersdale exists; he died in 1604 and lived at Doe Park.

By 1645, the house and surrounds were owned by James Ledgard, who was a Roundhead rather than a Royalist, and altered the house significantly, naming it Ledgard or Ledger Hall. Before he could complete works to the house, it is alleged that he was captured and met a grisly end on Romaldkirk Green where he was hung, drawn and quartered. With the house unfinished and money in short supply, works were completed much more rapidly

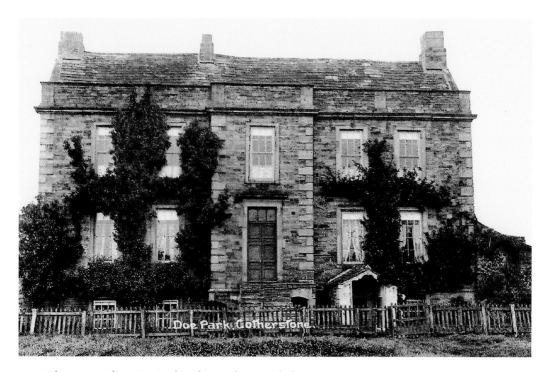

The outstanding Doe Park, a former hunting lodge.

and it is assumed that the house would have been intended to be much larger. With such changes forced upon the family, it was constructed taller but quite narrow.

The will of John Lax of Doe Park was recorded in 1816 and a William Hutchinson is recorded as owner in 1826 in the *Gentleman's Magazine*. A description of Doe Park in 1856 describes it as 'adjacent to a public road north of Cotherstone. A small walled garden and building are depicted south-west of the main house. The grounds around the house are not laid out to ornamental design'. The layout of the site has changed little over the years until the addition of a caravan park by the Lamb family. The name Doe Park is still a mystery, with no reasoning for this in any records to date.

57. Thwaite Hall
Thwaite Hall was one of the seats of the Huddlestons, whose principal residence was Millom Castle. Sir William Huddleston was a zealous and devoted Royalist during the Cromwellian wars; he raised a regiment of horses for the service of his sovereign, as well as a regiment of foot; and the latter he maintained at his own expense. At the Battle of Edgehill he retook the royal standard from the enemy, and for this act of personal valour he was made a knight banneret by the king on the field.

58. The Butter Stone
Located on Cotherstone Moor is a grooved, roughly-pyramidal boulder of less than a metre high. Known locally as the Butter Stone, this boulder was used during the 1663–65 plague as an exchange point where the inhabitants of Barnard Castle could leave money for produce left by the farmers of the region without the two groups ever meeting.

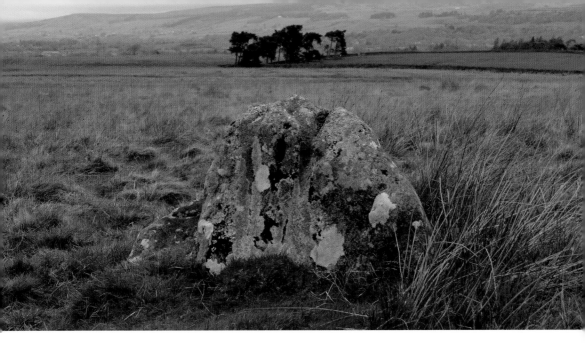

Looking back towards the village from the Butter Stone today – little has changed.

Town markets had been closed to reduce infection, and safe places to exchange goods were organised in isolated spots. Farm produce could be placed at the stone, and the seller retreated to a safe distance while the buyer took the goods and left coins in a bowl on the stone. The bowl was probably full of vinegar, to disinfect the coins. Butter must have been the most important produce, but all sorts of things were likely exchanged or sold. Other accounts say that the goods were placed on the stone, but there just isn't room for more than a few eggs and a couple of pounds of butter.

59. The Christening Stone

Wayside crosses are one of several types of Christian cross erected during the medieval period, mostly from the ninth to fifteenth centuries AD. In addition to serving the function of reiterating and reinforcing the Christian faith among those who passed the cross and of reassuring the traveller, wayside crosses often fulfilled a role as waymarkers, especially in difficult and otherwise unmarked terrain. The crosses might be on regularly used routes linking ordinary settlements or on routes having a more specifically religious function, including those providing access to religious sites for parishioners and funeral processions, or marking long-distance routes frequented on pilgrimages.

The commonest type includes a round, or 'wheel', head on the faces of which various forms of cross or related designs were carved in relief or incised, the spaces between the cross arms possibly pierced. The design was sometimes supplemented with a relief figure of Christ and the shaft might bear decorative panels and motifs. Most wayside crosses have either a simple socketed base or show no evidence for a separate base at all. Wayside crosses contribute significantly to our understanding of medieval religious customs and sculptural traditions and to our knowledge of medieval routeways and settlement patterns.

The Christening Stone.

Just east of Doe Park is found what is known locally as the 'Christening Stone'. It is the only example on the route between Cotherstone and Romaldkirk to survive in its original position and display a clear association with the original medieval routeway. The monument stands in an area of undisturbed ground. It includes the socket stone of a cross, the upper edge being chamfered and a benchmark is present on the north face. The name of the cross comes from the past tradition of the symbolic christening of a calf as part of the May Day celebrations. In *The History of the Antiquities of the Parish of Darlington* it is referenced 'Cotherston, where they christen calves, hopple lops and kneeband spiders'. It is an unusual phrase, but apparently some locals did carry out such acts in contempt of the ritual of baptism. They did indeed christen calves here, but others suspect it was used as a resting place for coffins being carried on their way. Either way, it is a fascinating piece of Cotherstone history and it is worthy of its Grade II listing.

60. Lathbury, Moor Road

Since the middle of the nineteenth century Lathbury has been associated with the Quaker family by the name of Chipchase. It was John Chipchase who moved to Lathbury, having initially worked as a draper in Stockton-on-Tees and then as a schoolteacher, where he opened a school in his home town. In 1831, he married Alice Robinson. Receiving a moderate inheritance from a distant relative, he moved to Lathbury, Cotherstone, where he devoted much of the remainder of his life to educating his children. Alice died in 1853 and

John married Ann Brantingham, who died several months later. In 1852, John was recorded as a minister, the character of his ministry described as 'persuasive and fervent'. He died on 2 March 1862 and was buried in the Friend's burial ground in Cotherstone.

One of the more celebrated of the Chipchase family was Sarah Chipchase Walker (1879–1919). Her obituary read:

Sarah Chipchase Walker of Glasgow, late of Harrogate, the daughter of Benjamin Walker and Sarah Walker (nee Chipchase), was educated at Ackworth and The Mount, and loved both schools. After some private teaching she opened a school in Harrogate, but on the death of her mother went to Glasgow, where she held an important position in the Junior School at the Academy. She was President of the Women's Adult School in Harrogate, worked unceasingly for Peace and Internationalism, President of the W.I.L. (Women's International League), Glasgow, and active member of emergency and other committees. After a life of perfect health her illness came as a shock to her large circle of friends. She seemed so radiant and full of energy. Undoubtedly she is a victim of the war, and has laid down her life in the interest of others. She leaves a legacy of good-will and sunshine, of brightness and beauty of spirit that will never die.

She died at Hillhead, Glasgow, on 3 December 1919, at the age of forty.

Lathbury and its once ornate gardens.

61. Remains of the former British Legion Hut

What might seem a fairly unimportant remnant of a building is the former Legion Hut in one of the village back lanes, adjacent to the telephone exchange. It was once the home to the men and women's British Legion, as well as a youth club and other functions. However, it also had another role towards the end of the Second World War, as a place where Italian prisoners of war were held. Sadly now a ruin after a fire many years ago, all that remains is a charred ruin.

The sad remains of the former British Legion hut, once a home for Italian prisoners of war.

4

People and Community

For such a small village, over the centuries it has been known for a number of well-known residents. The Fitz Hughs, Bournes, Lingfords, Chipchases and the Gibsons have been previously referred to. Among these notable residents we should include mountaineer Bentley Beetham, philanthropist Abraham Hilton, architects Maxwell Fry and his wife Jane Drew, the Birkett family, criminal lawyer Sir John Cyril Smith and, of course, our very own daleswoman Hannah Hauxwell.

John Cyril Smith was born in the village in 1922. He was an authority on English criminal law and the philosophy of criminal liability. Together with Brian Hogan he was the author of *Smith & Hogan's Criminal Law*, a leading undergraduate text on English criminal law. The book is now in its fourteenth edition (2015) and has been used as persuasive authority on crimes prosecuted in the law courts of England and Wales and elsewhere in the common law world. In 1998, Lord Bingham praised Smith: 'Whom most would gladly hail as the outstanding criminal lawyer of our time.'

Bentley Beetham, the mountaineer, ornithologist and photographer retired to Cotherstone in 1949. He was a member of the 1924 British Mount Everest Expedition. It is occasionally thought that he spent his childhood at Balder Grange, but this was never the case. Away from the mountains, Barnard Castle School was the centre of Beetham's life, and he was often resident here during term time. According to a biography on him written in 2007, it was to 'Balder' in Cotherstone that he retired, to Balder Cottages, just below the West Green.

Abraham Hilton was a kind-hearted tea and spirit merchant who lived a simple life but was always ready to give handouts to poor families as he travelled around the district. Despite giving away such vast amounts, when he died in 1902 he was worth well over £2 million in today's calculations. His will directed that the bulk of it should be used to provide pensions of up to £15 a week for needy men and women. He named the first four pensioners as his own servants – Thomas Robson, Emma Wright, Jane Wright and James Aislaby. The fifth was Sarah Gibson, who was also allowed to live the rest of her days in a house he owned in Bowes. Other pensions were to go to 'deserving or necessitous' folk who were not getting poor law relief and who, from ill health, accident or infirmity, were unable to maintain themselves by their own exertions. Those to be assisted were not just

Teesdale residents but others in Caldwell, Eppleby, Melsonby, Middleton Tyas, Barton, Reeth and the upper part of Swaledale. He also left £40 apiece to five of his friends who were executors of the will and had to ensure that the right pensioners were selected. They were Christopher Martin, George Bainbridge, Robert Hopkinson, John Ingram Dawson and Thomas Chipchase. Hilton was the last of his line, with no heirs or other relatives. He is buried in a grave above the River Tees near Tees Mill, which was part of the Three Chimneys Charity, which Hilton was a founder of. 'Abraham Hilton of Barnard Castle, the founder of several local charities, who died on 1 Oct 1902, aged 87 years. Buried here by his own wish.' He lived at No. 33 Galgate in Barnard Castle.

Edwin Maxwell Fry, known as Maxwell Fry, was an English modernist architect, writer and painter who originally trained in the neo-classical style of architecture. Fry grew to favour the new modernist style, and practised with eminent colleagues including Walter Gropius, Le Corbusier and Pierre Jeanneret. Fry was a major influence on a generation of young architects. Among the younger colleagues with whom he worked was Denys Lasdun.

In the 1940s Fry designed buildings for West African countries that were then part of the British Empire, including Ghana and Nigeria. In the 1950s he and his wife, the architect Jane Drew, worked for three years with Le Corbusier on an ambitious development to create the new capital city of Punjab at Chandigarh. Fry's works in Britain range from railway stations to private houses to large corporate headquarters. Among his best-known works in the UK is the Kensal House flats in Ladbroke Grove, London, designed with Walter Gropius, which was aimed at providing high-quality low-cost housing, on which Fry and Gropius also collaborated with Elizabeth Denby to set new standards. Fry's writings include critical and descriptive books on town planning and architecture, notably his *Art in a Machine Age*. His last book, *Autobiographical Sketches*, was of his life from boyhood

Abraham Hilton, philanthropist.

Hilton's grave today, overlooking Tees Mill.

up to the time of his marriage to Jane Drew. On his retirement in 1973, Fry and his wife moved from London to West Lodge in Cotherstone, where he died in 1987 at the age of eighty-eight.

In April 1970, the *Yorkshire Post* published an article that chronicled the life of **Hannah Hauxwell**, who at the time was forty-four years old. She worked alone in her family home – Low Birk Hatt Farm, a dilapidated 80-acre farm in Baldersdale, many miles to the west of Cotherstone. She had run the farm by herself since the age of thirty-five following the deaths of her parents and uncle. With no electricity or running water and struggling to survive on £240–280 a year (equivalent to £4,365 in 2022) – at the time, the average annual salary in the UK was £1,339 (equivalent to £22,156 in 2022) – life was a constant battle against poverty and hardship, especially in the harsh Pennine winters, when she had to work outside tending her few cattle in ragged clothes in temperatures well below freezing.

In the summer of 1972, Hauxwell was discovered by a friend of a researcher at Yorkshire Television while out walking in the Yorkshire Dales. The researcher contacted Barry Cockcroft, a producer at the company, who proposed to make a television documentary tentatively entitled *The Hard Life*. The documentary, eventually called *Too Long a Winter*, started with her leading a cow into a shed during a blizzard in Baldersdale. After the documentary was first shown in 1972, Yorkshire Television's phone line was jammed for three days with viewers wanting to find out more and help her. ITV received hundreds of phone calls and mail containing gifts and money for 'the old lady in the Yorkshire Dales'. A local factory raised money to fund getting electricity to Low Birk Hatt Farm, and she continued to receive thousands of letters and donations from well-wishers around the world.

Almost two decades after *Too Long a Winter*, in 1989, the same television crew returned to her farm to catch up with Hauxwell. The second documentary, *A Winter Too Many*, saw that Hauxwell had a little more money, which she had invested in a few more cows. The crew followed her to London where she was guest of honour at the Women of the Year gala. Out of the spotlight, however, her work on the farm continued, and each winter became harder for her to endure. She commented, 'In summer I live and in winter I exist' in the film, which also showed her departure just before Christmas 1988. With her health and strength slowly failing, she had to sell her family farm and the animals she adored and move into a warm cottage in Cotherstone.

In 1992, director Barry Cockcroft once again ventured into Hauxwell's life making a documentary series that followed Hannah on her first trips outside of the UK. She visited France, Germany, Austria, Switzerland and Italy, during which she met the pope. The series proved so popular it was followed by another trip, this time to the United States in 1994, filmed as *Hannah:USA*.

After selling her farm and land Hannah was comfortably off and settled into her little cottage in Cotherstone, less than 5 miles from Low Birk Hatt Farm, where the meadows, designated a Site of Special Scientific Interest, are now called 'Hannah's Meadows' and managed by Durham Wildlife Trust. A book, *Hannah Hauxwell – 80 Years in the Dales*, was published in 2008. A new DVD, *Hannah Hauxwell – An Extraordinary Life*, featuring *Too Long A Winter*, *A Winter Too Many* and *Innocent Abroad*, was published. Hauxwell was interviewed on *Woman's Hour* in March 2008. To mark her eighty-fifth year she was

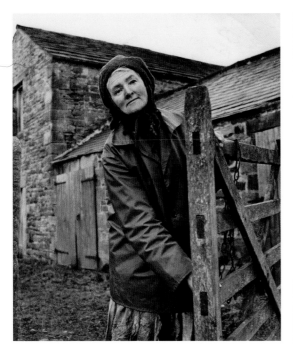 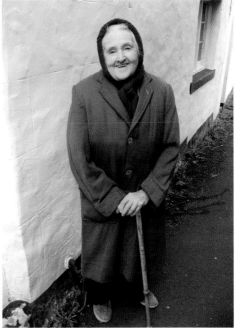

Above left: Hannah at Low Birk Hatt.

Above right: Hannah outside her cottage in Cotherstone.

interviewed by the *Yorkshire Post* and revealed that she was still living a frugal life and remained an avid radio listener. She moved to a care home in Barnard Castle in 2016, and to a nursing home in West Auckland the following year. She died there on 30 January 2018. After a funeral service at Barnard Castle Methodist church, Hannah Hauxwell was laid to rest at Romaldkirk cemetery.

In the twenty-first century, Cotherstone is a very different village from the days when it was known as 'Little Sunderland'. In 2001, the population was 552, by 2011 it was 594 and in 2021 it was 580. The last census indicated a largely older population. 18 per cent are between the ages of fifty and fifty-nine and 21 per cent are between sixty and sixty-nine, and 20 per cent are seventy years and older. These changes are manifested by the loss of shops in the village, with not a single facility remaining, Barnard Castle the centre of any localised retail opportunities, and of course, online shopping. In 1987, while studying Geography at Sheffield City Polytechnic, Paul Rabbitts wrote an article for the *Teesdale Mercury*, describing the changes in the villages in Teesdale, including Cotherstone, citing the impact of 'gentrification' but also the changes from many couples retiring here – this he termed 'geriatrification'. The response in the subsequent letters page elicited a somewhat hostile reaction from many residents. However, the evidence was overwhelming: loss of shops, school closures (Mickleton, Eggleston and Romaldkirk), closure of post offices, petrol stations, churches amalgamated, buses reduced adding to the rural isolation for many and the growth of holiday cottages. Yet today, Cotherstone is thriving, despite these changes. The one constant is change. Many families have now settled here, although often work elsewhere. The school continues to succeed, with fifty pupils studying here in 2022. The Cotherstone fun weekend is an annual success and both pubs are still popular. The village hall is well used. The neighbourhood plan submitted of 2020–2035 describes Cotherstone as 'Notwithstanding its growth and development, Cotherstone still exhibits significant evidence of its history and origins, from its traditional village greens and linear development along the main road, to its surrounding medieval pattern of strip fields, back lanes and tofts.' New houses have been built, with over forty dwellings added between 2005 and 2017. The plan identifies a vision: 'The vision for the Parish of Cotherstone is of a place with the facilities, amenities and opportunities to help support a thriving and cohesive community. It will strive to cherish, preserve and enhance its essential rural character and setting and its wealth of heritage and natural assets for the benefits they bring to all who live, work within and visit the area.' The closure of the village shop and post office, however, was a significant loss.

It is the wealth of heritage and natural assets that has contributed to one of Cotherstone's most famous assets – Cotherstone cheese. A quick search of Cotherstone in Google and it is the cheese that is most often referenced. *North Country Lore and Legend*, in February 1891, states: 'And the Cotherstone cheese, some of it is hardly inferior to Stilton. It is made by all the housewives at the surrounding farmhouses, and then it goes forth to the world to make the name of Cotherstone famous.' Surplus milk from local cows after milking was used to make the cheese and it was then sold locally. It was the Birketts at West Park, and in particular Dorothy Birkett, who took the production of Cotherstone cheese to a more commercial level, shipped out from Cotherstone railway station. Certain pastures were deemed more desirable and the cows grazed and the cheese produced from these was often in great demand and commanded a greater price. Cotherstone cheese is one of only a

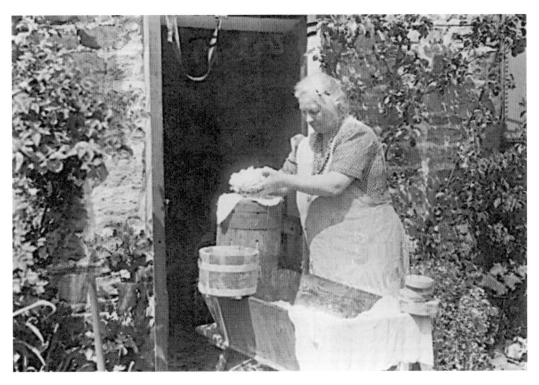

Mrs Birkett at West Park.

Traditional Cotherstone cheesemaking, keeping the village on the map even today.

handful of traditional types of Dales (valley) cheese still in existence today. Joan Cross has been making the cheese at Quarryhouse farm for over thirty years. She learned the recipe from her mother. Although there have been a few changes over the years, namely with the starter culture, advent of pasteurisation, and the use of vegetarian rennet, the basic cheese recipe remains similar to when her mother used to make it.

One other industry that remains in Cotherstone is the manufacture and construction of timber buildings by W. S. Hodgson & Co. Ltd. It was in 1906 when two local craftsmen responded to farmer's demands for small to medium-sized poultry houses. They had to be made from seasoned timber to withstand the weather, easily transportable and simple to construct. These craftsmen soon came to the conclusion that there was a great demand for their skills and, above all, their product. It was not long before they expanded into designing and building larger and more impressive buildings. It was William Hodgson and his son Alan Hodgson who founded the company, and it remains in the family to this day, exporting buildings as far away as the Falkland Islands in the South Atlantic.

The final word rests with Teesdale poet Richard Watson in his poem 'The Teesdale Hills'. These hills, which stand over our village, are very much part of this picturesque scene.

I've wandered many a weary mile,
And in strange countries been,
I've dwelt in towns and on wild moors,
And curious sights I've seen;
But still my heart clings to the dale,
Where Tees rolls to the sea,
Compared with what I've seen I'll say
The Teesdale hills for me
And at the heart of these hills, lies Cotherstone – a village in Teesdale.

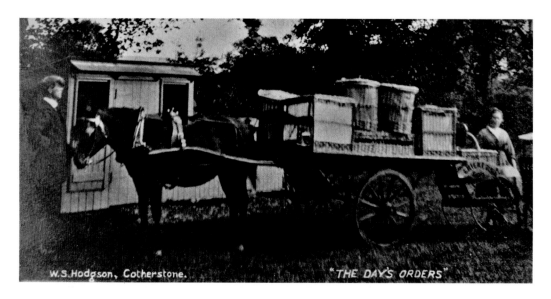

W. S. Hodgson and early days.

Bibliography

Books

Aslet, Clive, *Villages of Britain – The 500 Villages That Made the Countryside* (Bloomsbury: London, 2016)

Backhouse, James, *Upper Teesdale – Past and Present* (Simpkin, Marshall, Hamilton, Kent & Co.: London, 1896)

Bennett, E. N., *Problems of Village Life* (Williams and Holgate: London, 1917)

Burke, John, *English Villages* (Readers Union: Newton Abbot, 1975)

Chapman, Vera, *Cotherstone Village Past and Present* (High Force Publications, 1986)

Chapman, Vera, *Old Cotherstone – A Village Walk* (1984)

Chapman, Vera, *Teesdale Villages and Countryside – In Old Picture Postcards* (European Library, 1997)

Coggins, Denis, *Teesdale in Old Photographs* (Alan Sutton: Stroud, 1990)

Cotherstone Revisited (Heritage Lottery Fund: 2008)

Extracts of the minutes and proceedings of the yearly meetings of Friends, held in London, 1857

Hoole K., *North Eastern Branch Line Termini* (OPC, 1985)

Hoole K., *Railway Stations of the North East* (David & Charles: 1985)

Page, Robin, *The Decline of an English Village* (Quiller; Shrewsbury, 2019)

Parker, Malcolm; Tallentire, Lorne, *Teesdale and the High Pennines*, Discovery Guides Ltd

Raine, Parkin, *Teesdale – A Second Selection in Old Photographs* (Alan Sutton: Publishing, Stroud, 1994)

Ramsden, Allan, *A Guide to Places of Interest and Beauty Near Cotherstone, Romaldkirk and Egglestone*, Hood & Co. (Middlesbrough, 1920)

Ramsden, Douglas M., *Teesdale*, Museum Press Ltd (London, 1947)

Rudd, Michael, *The Discovery of Teesdale*, Phillimore (Chichester, 2007)

Stables, Andrew Graham, *Secret Barnard Castle & Teesdale* (Amberley Publishing: Stroud, 2018)

Warwick, Tosh, and Parker, Jenny, *River Tees – From Source to Sea*, Amberley Publishing, Stroud, 2016

Watson, Richard, *Poems and Songs of Teesdale* (Dresser & Sons: Darlington, 1930)

Websites

genealogy.com/forum/surnames/topics/huddleston/1915

british-history.ac.uk/vch/yorks/north/vol1/pp117-127#p31

thenorthernecho.co.uk/history/railway/stockton/3166699.southern-quaker-helped-shape-
 north/

teesdalemercuryarchive.org.uk/

quakerwalker.com/biographies/b65-benjamin-walker

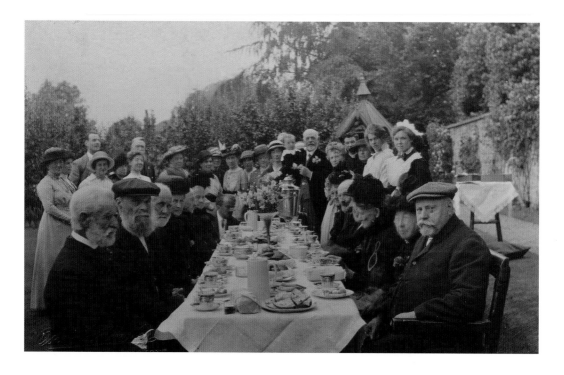

Above: A village tea party at The Limes held by the Howards.

Left: Cotherstone Carnival – the village is alive and kicking.

Acknowledgements

The authors would like to thank the following for contributing towards the publication of this book: Amanda Ainsley; Jeanette Aron; Richard Bell; Sarah Blanshard; Richard and Daphne Boothroyd; Mick Brennan; Malcolm Cawthra; Matthew Dodds; Denise Dowd; Judith and Phil Fanner; Julietta Federico; Liz Gordon; Edward Green; Fiona Green; Kelly Green; Simon Green; Geoff Hetherington; Paul Hindle; W. S. Hodgson & Co. Ltd, Cotherstone; Clare Iley-Christie; Claire Johnson; Robert Johnson; Tracey Jolliffe; Lee Knieriem; Jennie Lee; P. J. Leech; Malcolm J. Lorimer; Gillian Lyon; Fiona McKenzie; Simon Meacham; Gypy Majumdar; B. B. Mauthoor; Deborah Miller; Patrick Neill; Mrs J. A. Lees; David Nicholson; Carole O'Reilly; Amanda and Richard Pinkney; Brian Rabbitts; David Rabbitts; Ellie Rabbitts; Holly Rabbitts; Julie Rabbitts; Morlene Rabbitts; Paul Rabbitts; Nimalka Rambukpotha and Alan Marham; Gemma and Ollie Richardson; Kim Richardson; Shaun Rogers; Julie Romano; Jackie Sartin; Nicholas Scott-Gray; Bernard Sheridan; Mark Siswick MBE; The Siswick family; Pauline Smith; Andrew Graham Stables; Neil Stevenson; Frances Thin; Gordon Thomson; Brenda Thwaites; Gerry Thwaites; Mark Thwaites; David Robert Tomlinson; Mark Vallack; Philip Wade; Suzanne Walker; and Ella Watson.

We would also like to thank the *Teesdale Mercury*, Brenda Thwaites, Mark Siswick MBE, the Fitzhugh Library in Middleton-in-Teesdale, Sunderland Archives, Gary Marshall and the Parkin Raine and Andrews Collection and Richard Laidler (for the front cover image and others) for their contributions.

About the Authors

Paul Rabbitts was born in 1965 in Cotherstone, at Glendale, the home that David and Morlene Rabbitts built in 1963. He attended Cotherstone County Primary School and Barnard Castle School. He is the author of twenty-eight books, ranging from subjects including public parks, bandstands, local history, architecture and biographies of Grinling Gibbons, Sir Christopher Wren and architect Decimus Burton. He is a Fellow of the Royal Society of Arts, the Royal Historical Society and the Landscape Institute. He is currently Head of Parks and Open Spaces for the City of Southend-on-Sea. A father of three children, he lives in Leighton Buzzard with his wife Julie and youngest daughter, Ellie. Ashley and Holly have since fled the nest making successful lives of their own in London and the Far East.

A Few of Paul's Memories of Cotherstone

I have so many fond memories of living in Cotherstone, and they are all happy ones. I was fortunate enough to be born here and the village was my playground. My earliest memories were of the butcher's shop where Dad worked with my Uncle Fred and Uncle Billy. Stock arriving 'on the hoof' whilst I ate ice cream from the village shop. It was how local butcher's shops operated then. It was all done on the shop floor. I can still smell it.

Glendale was heaven and I spent eighteen years there before I left for Sheffield City Polytechnic, which was a cultural shock. Cotherstone School and lessons with Madge Baum, who taught Dad all those years ago, and spending days with Andrew 'Wacker' Walker, playing football in Tommy Birkett's fields. I would spend many hours building dams in becks up towards Cotherstone Moor or down the ghyll behind Balder Grange Cottage. Tommy Birkett farmed West Park and I would wander up the road and watch milking time, sit on the mudguard of his old grey Fergie tractor or sit in the link box as we traversed the fields above Glendale. It was Tommy who ensured Dad had work outside the butcher's shop and made a piece of land available to build Glendale.

Dad and Mum then branched out and bought a small milk round which expanded over many years to include not just Cotherstone, but Romaldkirk, Eggleston, Lartington and

Mickleton. I loved the milk round although some of the early mornings before school were a bit tough. We branched out into farming poultry and sheep and weirdly have happy memories of the mucking out and spreading it across Tommy Birkett's fields – on our own grey Fergie tractor, which I had learnt to drive at the age of fifteen.

Cotherstone had a petrol station run by Kelvin Walker, a shop run by Billy and Margaret Chisholm and what became Hannah's cottage was a corner shop. Special treats were chicken in a basket at the Fox and Hounds. I waited until I was eighteen years old before I had a drink at the Red Lion. The village had its own policeman with PC Gerry Thwaites, the incumbent enforcer of local law. The Cotherstone Carnival was a regular event each year and Mum dressed me and my sister as mermaids in a big pram as she pushed it through the village as King Neptune. When I queried this, Mum insisted a mermaid wasn't a girl. I was first married at St Cuthbert's Church and I have attended several funerals there, bearing my dear Grandma from No1 The Close through the village to church. I could go on, but I will always be proud of my Cotherstone roots. It has been an absolute delight revisiting the village and doing this book with my dear Dad.

David Rabbitts was born in 1942 in the Wiltshire village of Zeals and moved to Cotherstone in 1946. He lived at Balder Grange Cottage for many years and moved into Glendale in 1964, the home he built with Morlene and has lived in to this day. Paul was born at Glendale in 1965, and hopes Dad and Mum will eventually erect a plaque to mark the occasion.

A Few of David's Memories of Cotherstone

My first memories were as a four-year-old. I was enjoying a swing, attached to the pear tree in front of our home in Zeals, Wiltshire. But more exciting than the swing was running up the lane to swing on the wire fence as I watched Spitfires and Fortresses taking off and landing on the airfield we lived next to. Little did I know then that shortly I would be even more excited by looking out of the bedroom window at Heatherlea, Cotherstone, and seeing the view of St Cuthbert's just down the road and the surrounding houses. It was 19 July 1946.

We had moved to Cotherstone to live at Balder Grange Cottage. Mum was quickly acquainted with Tommy Birkett as our 'chattels' were unloaded from the wagon. A thirty-minute conversation conducted in West Country dialect and Baldersdale twang resulted in each departing with neither having any idea of what the other was talking about, but were friends for life from then on. So Balder Grange and West Park was my playground as I grew up. I was at Cotherstone School from five years old to fifteen, when I left. Walking through the front door of Barnard Castle School to sit the second half of my eleven plus scared the wits out of me. I made sure I did not go there. A monumental mistake.

Meanwhile, I was growing up as a devout country lad. Shooting and fishing was the norm in our family. Up to the age of ten years old or so, I had to be home by 7:10 p.m. It mattered not where I was beforehand as the 'alarm clock' was the 7 p.m. last train thundering down from Romaldkirk to Cotherstone. You could not miss it, or the noise. It was of course a steam train.

So, I left school and the memory of Madge Baum still lives with me – what a wonderful person she was. I then went to work at the village butcher's shop and slaughterhouse, working alongside my elder brother, Fred Rabbitts, and for Billy Kidd, my brother-in-law. Yes, we did everything in those days, from slaughtering to manufacture and baking. Great memories from working in the centre of the village, at the centre of village life.

I played cricket for Cotherstone as a young lad and eventually for Barnard Castle. The village badminton club was thriving at the time. I loved those sports. The bells of St Cuthbert's rang. This time I was not part of the bell-ringing team, but walking down the aisle to the altar with Morlene at my side. It was 1964. Morlene and I, with no experience of construction, then took on the challenge of building our new home, Glendale, within sight of Balder Grange Cottage, where we have lived all our married life. Not many years later, the family, complete with the addition of Paul and Kim, were owners of the local milk round. What memories that furnished us with. We served the local area for twenty-two years to the day.

Finally, we have engaged in welcoming visitors to Glendale now for thirty-two years as a bed and breakfast. Now, as I grow old, I hope gracefully, I can look back at the day I gazed out of Mrs Langton's window at Heatherlea and remember how excited I was to find myself in a different part of the country, and now living in a strange and very different village. I had every reason to be excited. The village was called Cotherstone.

David Rabbitts and Paul Rabbitts at the meeting of the waters in 2021.